IMAGES
of America

RAILWAYS OF
SAN FRANCISCO

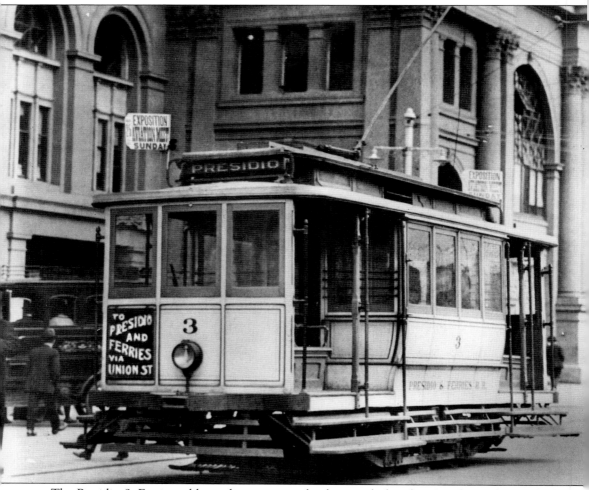

The Presidio & Ferries cable car line was completely ruined after the 1906 fire and was rebuilt as an electric streetcar line by 1907, using 29 second-hand single truck streetcars from the United Railroads. P&F No. 3 is at the Ferry Building.

IMAGES
of America

RAILWAYS OF SAN FRANCISCO

Paul C. Trimble

ARCADIA

Published by Arcadia Publishing
Charleston SC, Chicago IL, Portsmouth NH, San Francisco CA

Printed in Great Britain

Library of Congress Catalog Card Number: 2004103391

For all general information contact Arcadia Publishing at:
Telephone 843-853-2070
Fax 843-853-0044
E-mail sales@arcadiapublishing.com
For customer service and orders:
Toll-Free 1-888-313-2665

Visit us on the internet at http://www.arcadiapublishing.com

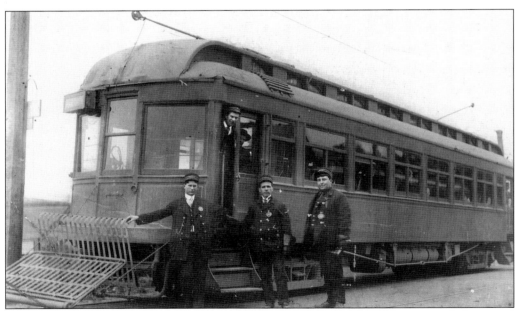

Four platform men pose with a Big Sub at Holy Cross Cemetery. The 40 Line provided easy and economical access to the cemeteries in Colma before the days of the ubiquitous automobile.

CONTENTS

This book is dedicated to my grandson, Nicholas George Mackechnie.

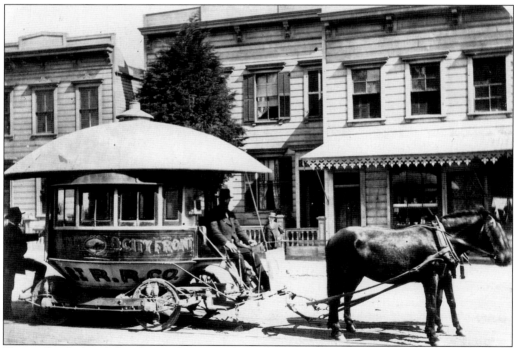

Henry Casebolt of the Sutter Street Railway designed this ingenious contraption called a balloon car. To reverse direction, the driver lifted a latch, which released a pivot, drove the horse in a half-circle, and replaced the latch without having to get out of his seat. The car was designed to attract distaff customers with its velvet upholstery, carpeting, and admonitions that gents could not ride unless accompanied by a lady. They were also to refrain from smoking cigars and spitting on the floor!

INTRODUCTION

Many are the images of street railway vehicles that grace libraries, museums and private collections, including the author's. To employ a well-known adage, any of these pictures may be worth a thousand words; yet they may say very little.

A photograph is an inanimate object, merely a capture of light reflected upon a piece of glass. The picture needs the story to be complete. What was this streetcar doing? Where was it from and where was it going? And sadly, why were the streetcars abandoned if they did such a wonderful job? To a certain degree, local photographers have answered these questions through their cameras, and rail historians forever shall be grateful to them.

The streetcars and their antecedents in San Francisco existed for a variety of reasons, including the raising of real estate values, as well as providing efficient and inexpensive transportation for workers, shoppers, students, and tourists. In so doing, these railways contributed to the city so profoundly that they could never be repaid, even if the fare had been doubled or tripled. In fact, fares that were kept artificially low by franchise requirements, along with the prosperity that enabled urban dwellers to purchase automobiles, were direct factors in the railways' own demise.

From the time of San Francisco's founding in 1776 by Spanish colonists until the Gold Rush Era, the city's urban transportation problems were solved by either walking or utilizing beasts of burden over streets that were little better than dirt trails.

The introduction of the horsecar in 1862 allowed for municipal expansion since the average speed of the horsecar was double that of walking, and not everyone owned a horse. The cable car made its debut in 1873 and almost doubled the speed of a horsecar, enabling citizens to travel four times the distance within the same amount of time.

At that time, vast acreages of San Francisco real estate could be developed simply because there was adequate transportation, provided there were sufficient investors to finance the construction of a street railway line. An 1887 study showed that real estate values within 200 feet of a cable car line jumped anywhere from 14 percent to 40 percent a year after commencement of service. That in itself was an incentive to invest in an urban railway.

The fact that the electric railway industry in the United States was a money loser after the year 1926 does not diminish the job the American streetcar services did–and did well. Why these mostly privately owned street railways lost money and were, for the most part, eventually abandoned is the subject for another book.

ACKNOWLEDGMENTS

The author is indebted to the many photographers, known and unknown, professional and amateur, who recorded these images over the years, as well as the rail historians who recorded the histories of these forms of urban transport. Thanks is given to all of them.

Unless otherwise noted, all pictures in this book are from the author's personal collection, and the photographers are cited wherever possible, commensurate with a good degree of accuracy. The author takes personal responsibility for any inaccuracies that may appear.

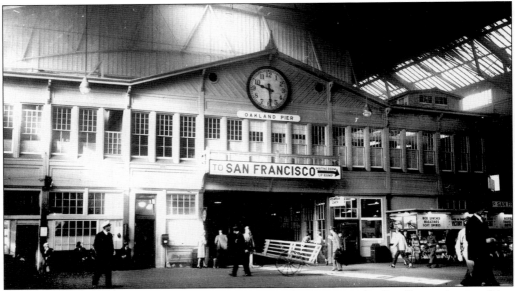

United Railroads streetcar No. 1423 poses at Five Mile House on the San Bruno Avenue Line in the early 20th century. (Courtesy of the late Charles A. Smallwood.)

One
IN THE BEGINNING

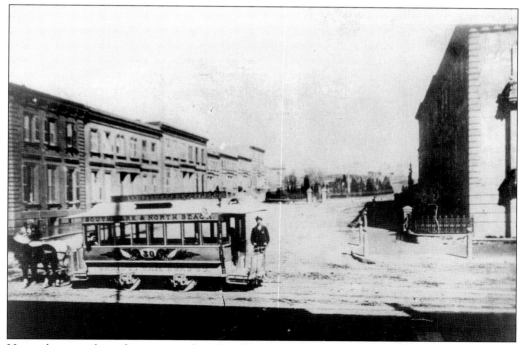

Horse drawn railcars first appeared on San Francisco streets in 1862. One of the earliest lines was the Omnibus Railroad, running from very fashionable South Park to North Beach, as shown in this 1865 photo.

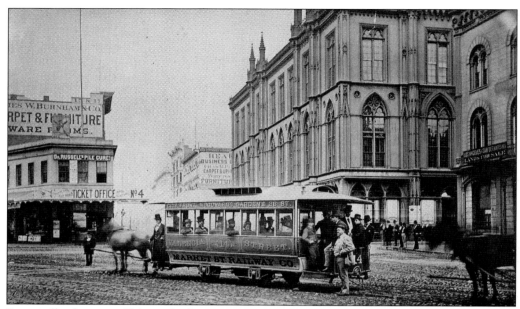

Eventually there would be eight horsecar companies in San Francisco, of which one, shown here, ran from the San Francisco & San Jose Railroad depot on Valencia Street to Market Street and down Market to the waterfront.

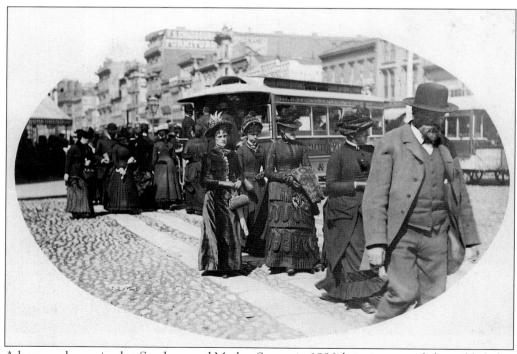

A horsecar has arrived at Stockton and Market Streets in 1886, bringing some fashionable ladies downtown for a day of shopping, lunch, and perhaps a matinee at one of the city's many theaters.

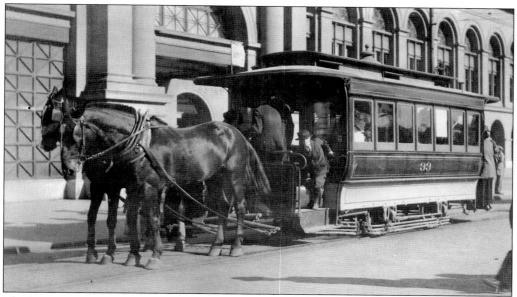

The horsecar managed to linger on in San Francisco more than two decades after the electric streetcar had rendered them obsolete. This car made a ceremonial last run on June 3, 1913, ending what progressive San Franciscans deemed a menace to street navigation.

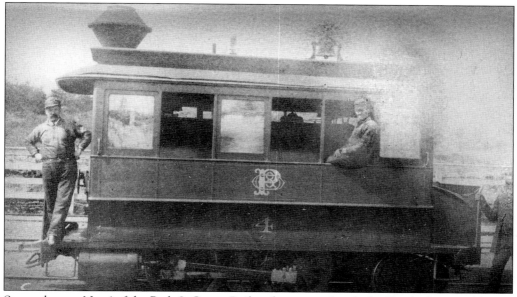

Steam dummy No. 4 of the Park & Ocean Railroad connected with the Haight Street cable cars at Stanyan Street to continue passengers along H Street (now Lincoln Way) on the southern border of Golden Gate Park to the western edge of the park near the Pacific Ocean.

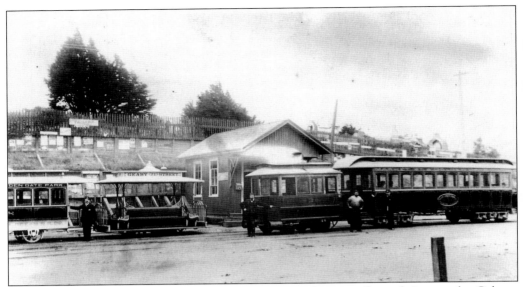

Until 1892 the Geary Street cable cars' outer terminal was at Central Avenue by Calvary Cemetery (background). In Victorian times, cemeteries served a dual purpose of urban parkland and repositories for the dearly departed. At Central, patrons could transfer to the company's steam trains to continue the journey to Golden Gate Park.

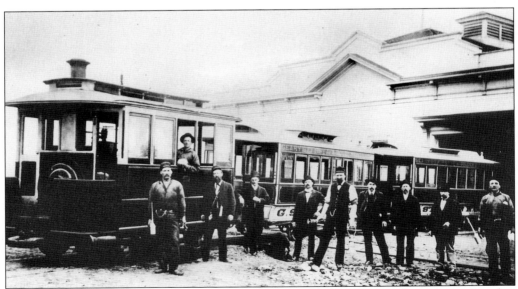

Steam dummies, or locomotives, were designed to resemble horsecars in the naïve notion that horses wouldn't be frightened of them. At the First Avenue and Geary Carhouse a cadre of hirsute employees and a dummy with a brace of trailers pose for posterity.

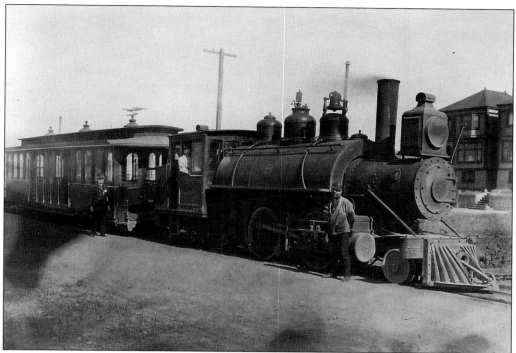

Another steam line was that of the Ferries & Cliff House Railway which took passengers from California Street and Presidio Avenue out California to Thirty-third Avenue, then over a private right-of-way to a terminal at what is now Forty-eighth Avenue and Seal Rock Drive. The man standing at the far right is John Francis Guerin, later superintendent of the Washington and Mason cable car facility. (Courtesy of John J. Crowley Jr.)

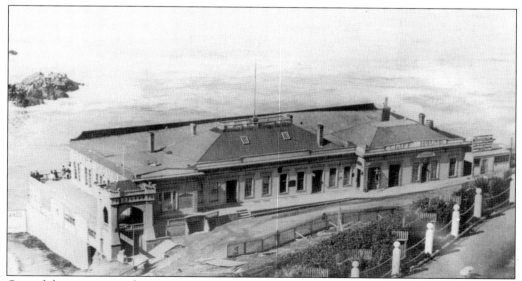

One of the attractions for patrons to ride the Ferries & Cliff House steam line was the second Cliff House, seen here from Sutro Heights, which was the estate of Adolph Sutro, a wealthy San Franciscan and philanthropist.

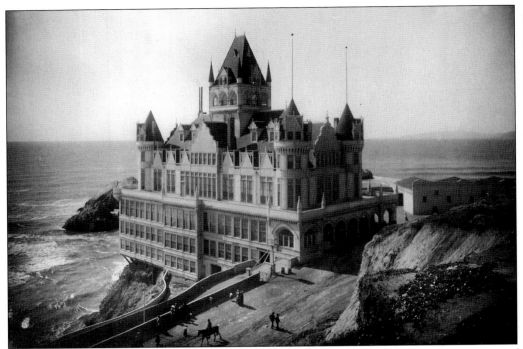

The third and most elaborate of the Cliff Houses was built in 1896. While to most it was one of the city's finest restaurants, there were stories of what Victorians termed "strange goings on" in the private dining suites.

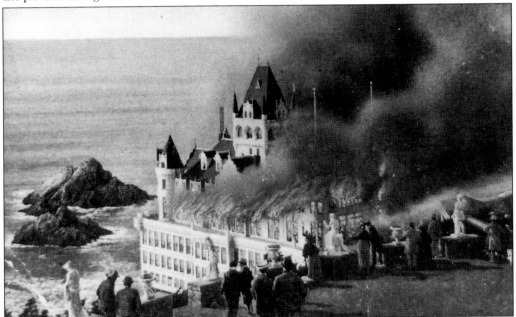

On September 7, 1907, San Francisco's answer to King Ludwig II's Neuschwanstein Castle in Bavaria, Germany, was lost in yet another of the city's memorable conflagration, only to be built again in a more simplified form.

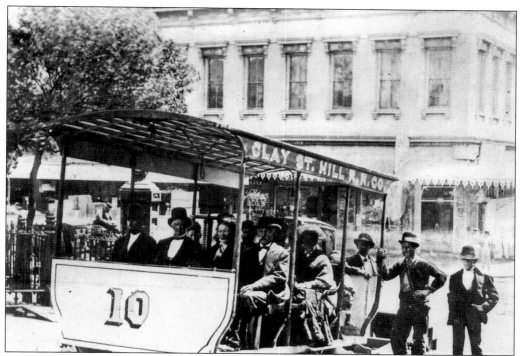

On August 1, 1873, the Clay Street Hill Railroad inaugurated cable car service on its namesake street. Dummy, or grip car, No. 10 is at the turntable at Clay and Kearny Streets. Seated at left in front is inventor Andrew S. Hallidie with Mayor Andrew Bryant and Mrs. Hallidie.

From Clay Street and Van Ness Avenue we see the housing density on the steep slopes of Nob Hill in the background, assuring the cable cars of enough customers to net the stockholders a 5 percent monthly return on their investments, all derived from a 5¢ fare. (Courtesy of the late Charles A. Smallwood.)

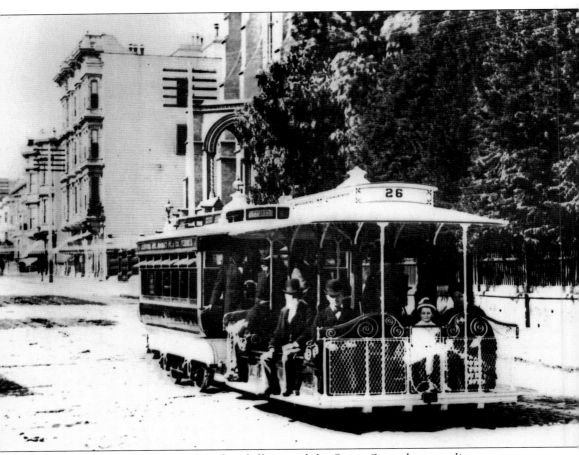

Economics and efficiency rather than hills caused the Sutter Street horsecar line to convert to cable car in 1877. Cable cars were twice as fast as horsecars and could hold almost double the number of passengers, meaning more round trips per crew. In this view, an eastbound cable car of the Sutter Street Railroad has just passed Temple Emanu-El and Vienna Gardens and is proceeding toward Stockton Street on its way to the downtown terminus at Sansome Street.

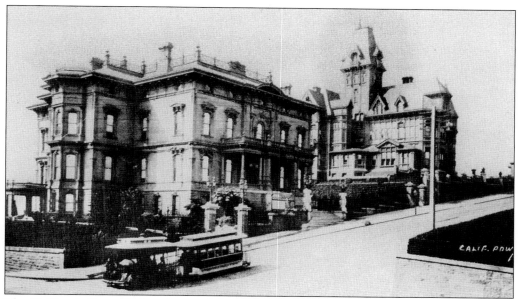

The California Street Railroad opened for business in 1878, operating cable cars on California between Kearny and Larkin Streets. This line was built by Gov. Leland Stanford who owned the magnificent Nob Hill palace on the left.

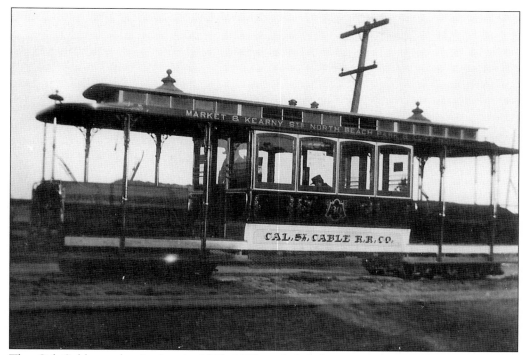

The Cal Cable modernization in 1890–1891 included this type of car with two open end sections and an enclosed center section, eliminating the dummy and trailer trains. This design became known in industry parlance as the California Type Car.

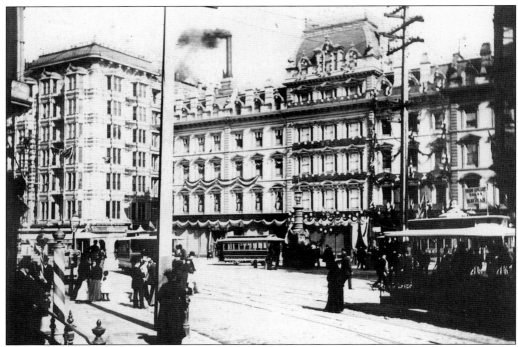

The intersection of Geary, Market, and Kearny Streets was the eastern terminus of the Geary Street, Park & Ocean Railroad's cable cars. In the center is Lotta's Fountain, which still stands, a gift to the city from singer Lotta Crabtree. (Courtesy of the late Charles A. Smallwood.)

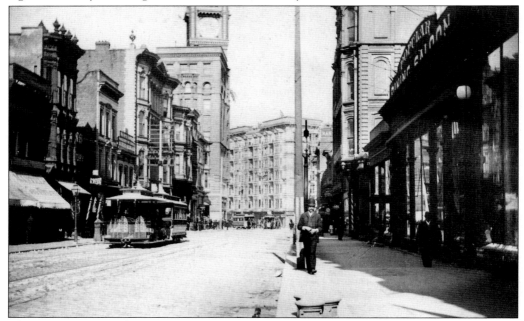

The Geary Street cable car is heading west, through the city's fashionable retail shopping district. The large building with the clock tower is the de Young Building, then the home of the *San Francisco Chronicle* and the city's first skyscraper.

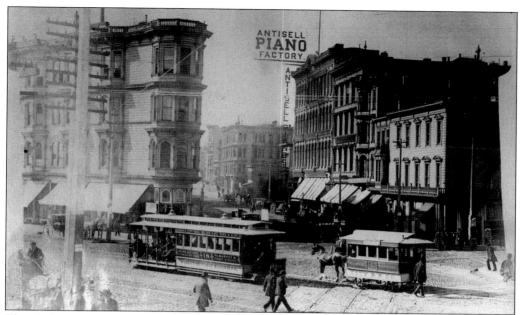

The city's most extensive cable system was that of the Market Street Cable Railway with five lines radiating off Market Street. This cable system was the first to combine the dummy and trailer into one vehicle, capable of holding 130 passengers at once. This photo was made in 1889.

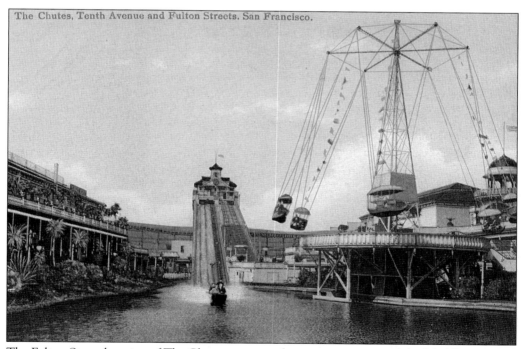

The Chutes, Tenth Avenue and Fulton Streets. San Francisco.

The Fulton Street location of The Chutes was one of two reasons to extend the McAllister Street cable line to Twelfth Avenue. The second was the Midwinter Exposition of 1894 in Golden Gate Park, and both attractions were serviced by the yellow cable cars from Market Street.

The San Francisco & San Mateo Railway was the city's first electric streetcar service. Early day streetcar bodies were similar to cable cars and were built by the same carbuilders. This is one of the cars that ran to Holy Cross Cemetery in Colma. (Courtesy of Randolph Brandt.)

Car No. 20 and crew of the SF&SM pose in front of the company's office at San Jose Avenue and Thirtieth Street, c. 1895. The conductor at the left is John J. Crowley Sr. (Courtesy of John J. Crowley Jr.)

Two

THE NEW
ELECTRIC STREETCARS

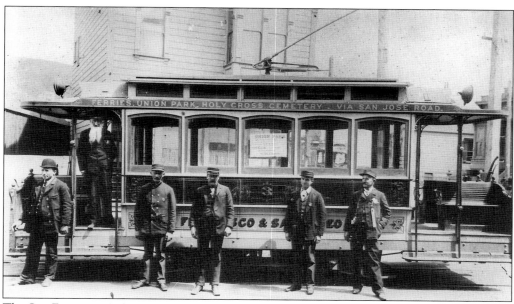

The San Francisco & San Mateo Railway began in 1891 and had a branch line to Golden Gate Park, later to become the city's first trolley bus line. The conductor at the right is John J. Crowley Sr. (Courtesy of the late Charles A. Smallwood.)

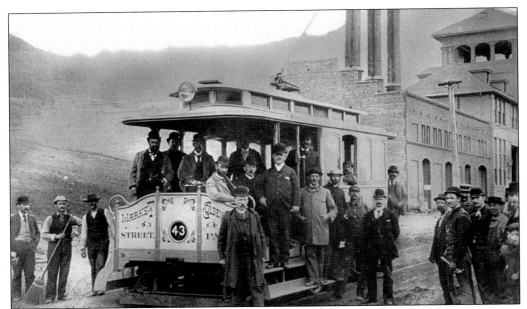

The Metropolitan Railway began in 1891 as the city's second electric line with a circuitous route from Eddy and Market Streets to Ninth Avenue and H Street (now Lincoln Way). A few relics of the line remain, but it takes a keen eye to find them. The company was absorbed into the Market Street Railway in 1894. (Courtesy of Emiliano Echevarria.)

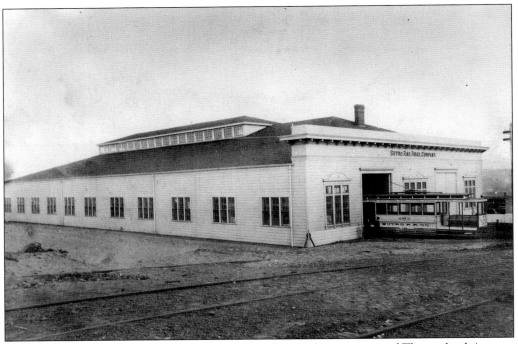

This was the carhouse for the Sutro Railroad, at the northwest corner of Thirty-third Avenue and Clement Street in the Richmond District, now the site of a supermarket. Built in 1895, it lasted until 1951 with little change. (Courtesy of the late Charles A. Smallwood.)

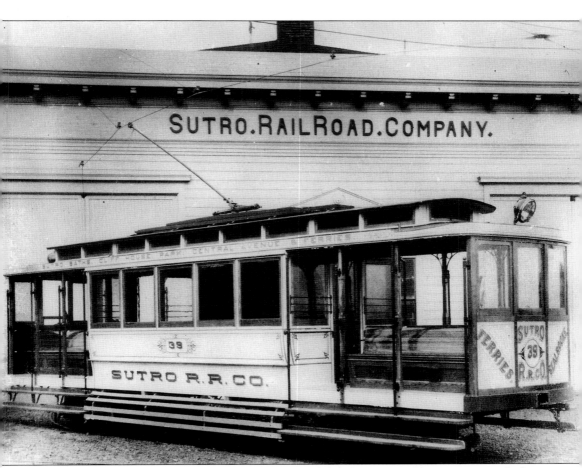

The Sutro Railroad was founded by Populist Mayor Adolph Sutro in 1896 to connect with the Sutter Street Railroad's cable cars and to bring people to Sutro's recreation complex near Seal Rocks. The company was soon bought by the Sutter Street concern, a rare instance of a streetcar company being purchased by a cable car company.

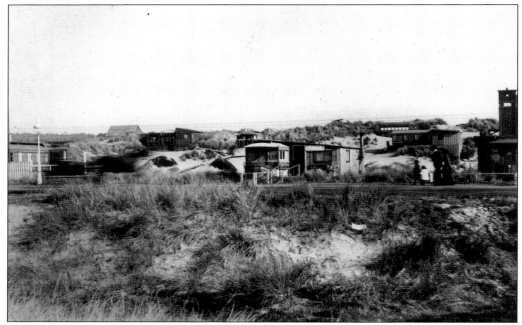

The first major amalgamation of the city's street railways happened in 1893, forming the Market Street Railway. Five cable car lines and most horsecar lines were converted to streetcars during the next few years. Some retired car bodies became cottages at Forty-eighth Avenue and Lincoln Way. (Courtesy of the late Charles A. Smallwood.)

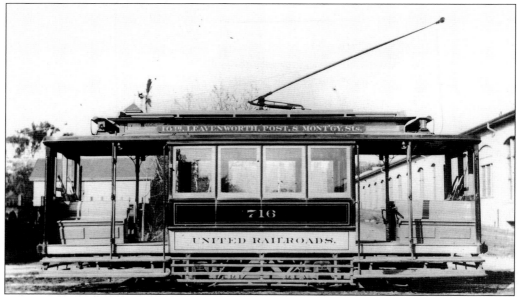

The United Railroads of San Francisco (URR) was formed in 1902 as the city's second major street railway merger, uniting the Market Street Railway, Sutter Street Railroad, and San Francisco & San Mateo Railway. No. 716 was a typical streetcar of that era: single-truck, a pair of 35-horsepower motors, and hand brakes. (Courtesy of the late Charles A. Smallwood.)

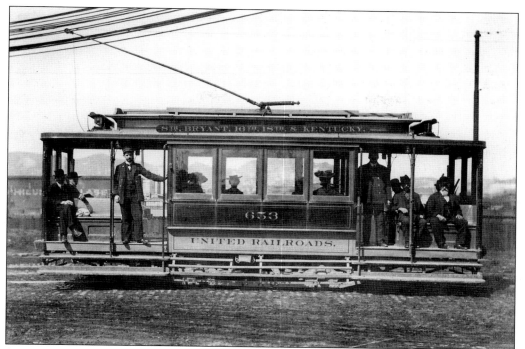

Soon most of the city's street railway cars wore the maroon and white paint with gold trim of the United Railroads, rather than each line having its own color scheme. This made for greater flexibility of rolling stock. (Courtesy of the late Charles A. Smallwood.)

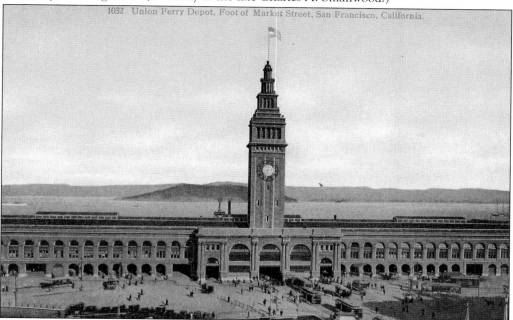

1032 Union Ferry Depot, Foot of Market Street, San Francisco, California.

For years the hub of the city's transit had been the old ferryboat shed at the foot of Market Street. In 1898 the landmark Ferry Building opened for business at the same location, and in this view the edifice greets both horsecars and cable cars.

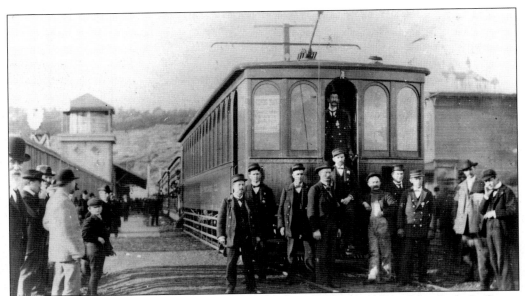

In 1898 the Market Street Railway electrified the former steam line of the Park & Ocean Railroad. The cars weren't junked, however; the company recycled them into electric cars, such as No. 601-603, shown here.

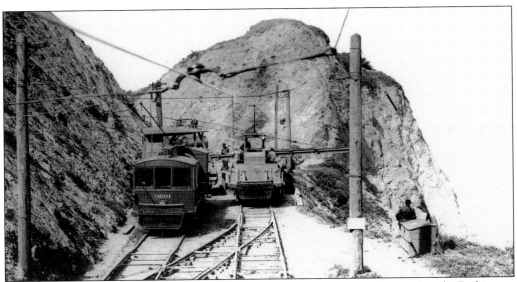

In 1905 the URR converted the former Ferries & Cliff House steam line to Land's End into a streetcar line. On a clear day the view was breathtaking.

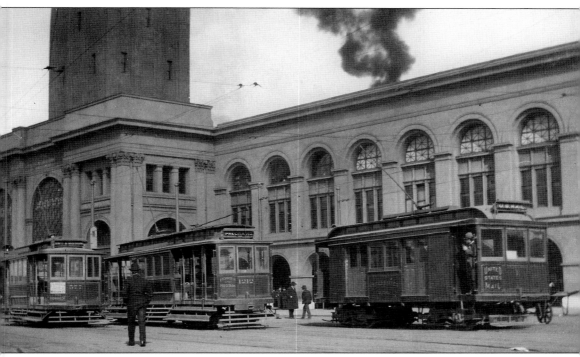

Just prior to the 1906 fire, three trolleys pose at the Ferry Building. No. 577 at left will go out Howard Street. No. 1212 was rebuilt from a cable car and will go on Folsom Street. At the right is Mail Car E, which brought sacked mail from the ferries to district post offices.

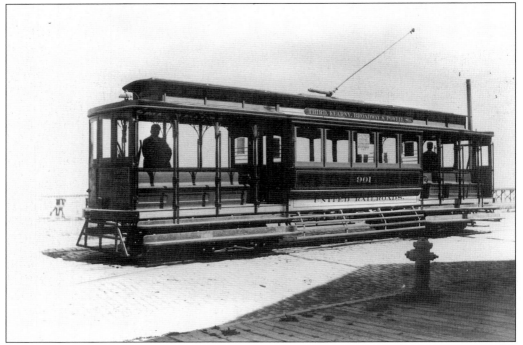

URR No. 901 was rebuilt from an Omnibus Cable Co. cable car into an electric streetcar and is marked for Third and Kearny Streets, ironic in that it was once an Omnibus horsecar line.

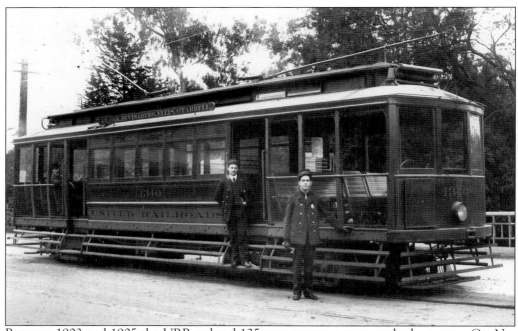

Between 1903 and 1905 the URR ordered 125 new streetcars to upgrade the system. Car No. 1340 was in the first job order and is posed on Stanyan Street next to Golden Gate Park. (Courtesy of the late Charles A. Smallwood.)

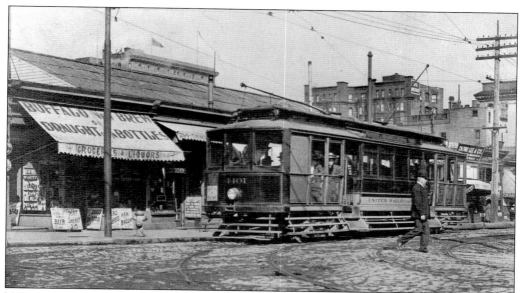

No. 1401 was built in 1905 and went to work on the Ellis Street Line, as seen here. The 1300 and 1400 series of cars were the first true streetcars in the city to be equipped with air brakes.

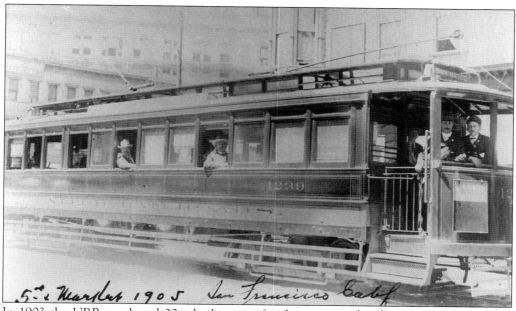

In 1903 the URR purchased 20 suburban cars for the just completed interurban line to San Mateo. Here No. 1239 of that group is at the new terminus at Fifth and Market Streets. These cars would run until 1949, albeit much rebuilt over the years.

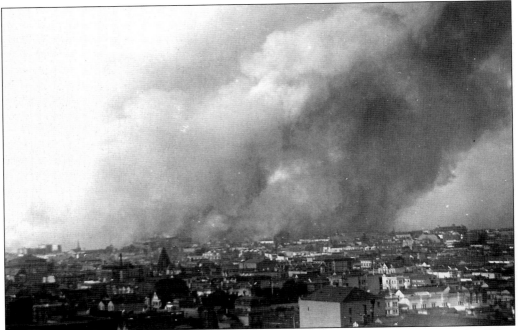

San Francisco was struck on the morning of April 18, 1906, by a devastating earthquake. What the earthquake didn't destroy, the ensuing fire set out to finish, culminating in the worst civil disaster to visit a modern American city. This photo was taken at 5:30 p.m. on April 18. (Photo by Walter Castelhun.)

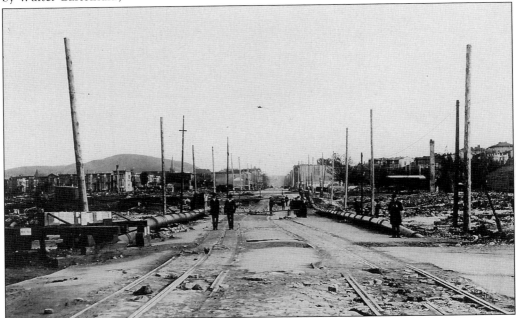

Looking south on Valencia Street into the Mission District, the cable car tracks are a mess. The United Railroads used this opportunity to convert seven cable car lines to electric streetcars as well as to upgrade most of the streetcar lines. (Photo by Walter Castelhun.)

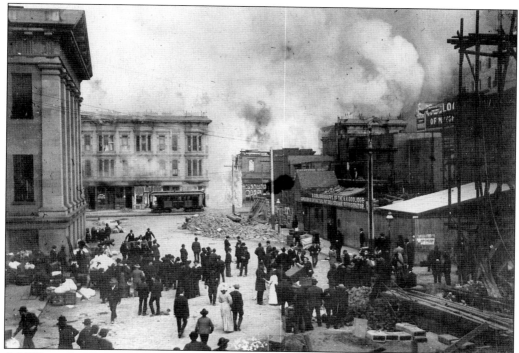

A URR mail car was stranded on Mission Street when the earthquake struck, shutting down all electric power. From this view in back of the U.S. Mint at Fifth and Mission Streets, the mail car awaits incineration. (Courtesy of the late Charles A. Smallwood.)

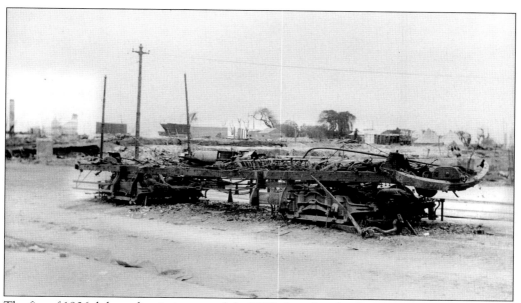

The fire of 1906 did not discriminate, and the URR shared in the devastation. The intense heat melted the copper trolley wires and burned streetcar No. 1310 to a crisp in the middle of Guerrero Street. (Photo by URR.)

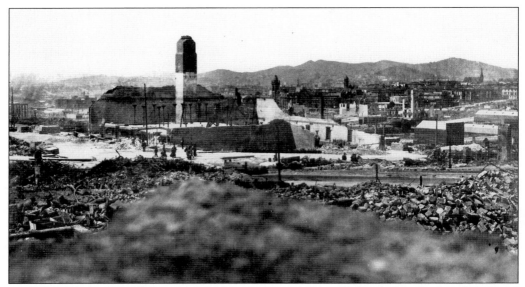

Looking west, this was all that was left of the California Street Cable Railroad's powerhouse and carhouse at Hyde and California Streets after the fire. Every one of the company's cable cars was lost, except for one obsolete grip car that would return to action, albeit temporarily. (Courtesy of the late Charles A. Smallwood.)

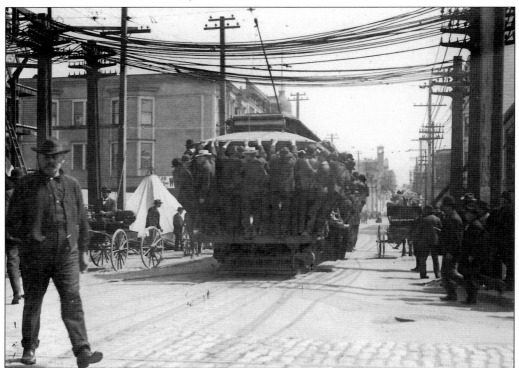

After 1906 the city was down but not out. Streetcar service was resumed on April 27 on the Fillmore Street Line. The first car is running at Turk and Fillmore Streets, and it seems as if everyone in town wanted to ride. (Courtesy of the late Charles A. Smallwood.)

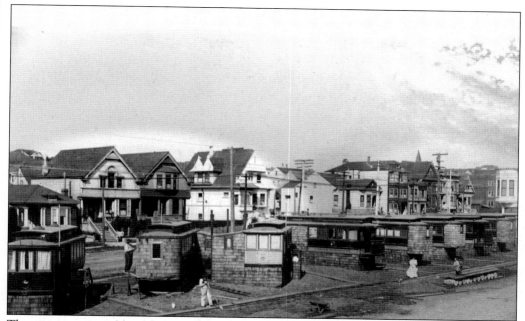

The narrow strip of land bounded by Cornwall Street (foreground), Fifth Avenue (east, to right), California Street (background), and Sixth Avenue (west, to left) provided the right amount of space for these nifty cottages in the city's Richmond District. After the fire the city had a severe housing shortage, and redundant cable cars were better than refugee tents in a city park. (Courtesy of the late Charles A. Smallwood.)

After 1906 a trio of cable car trailers on Ninth Avenue near Clement Street became the home of Charles and Alma Suggs. Condemned to make way for a city parking lot, the home was carefully dismantled, with two of the cars spared for historic preservation and the third used as a source for spare parts. (Photo by Paul C. Trimble.)

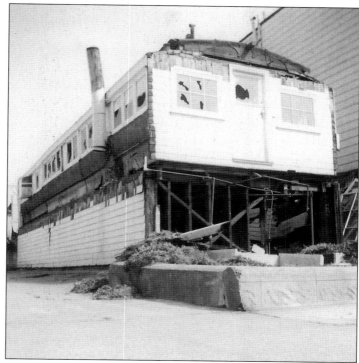

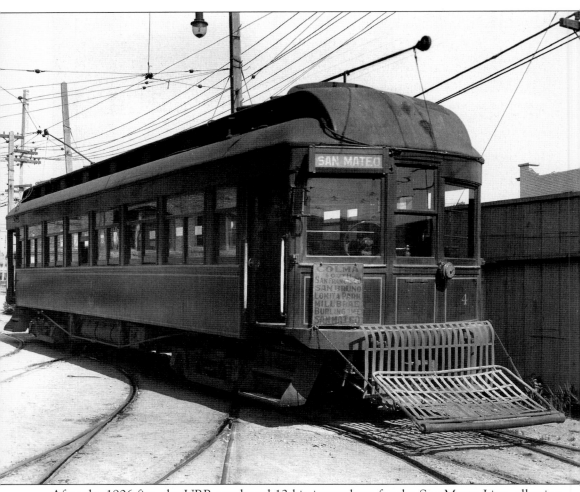

After the 1906 fire, the URR purchased 12 big interurbans for the San Mateo Line, allowing the 1225 class to be used in city service. At 75,400 pounds, they were quickly dubbed "Big Subs," short for Big Suburbans.

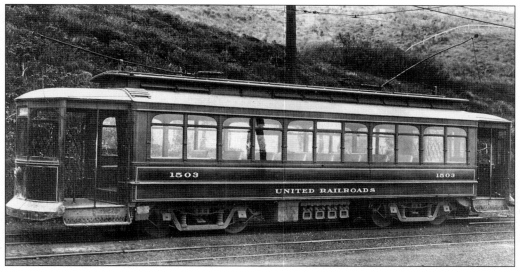

URR streetcar No. 1503 was one of 50 new streetcars built for Chicago but diverted to San Francisco after the fire as newer equipment was needed for an expanded streetcar system and to replace obsolete single truck cars. (Courtesy of the late Charles A. Smallwood.)

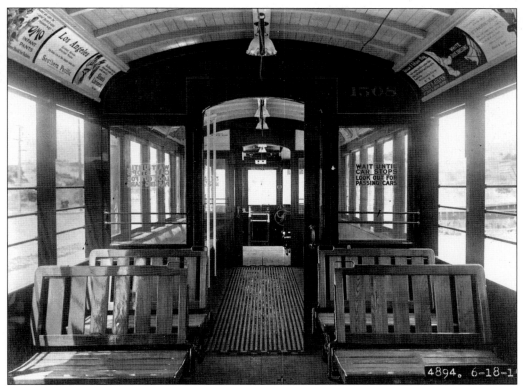

The interiors of the Chicago cars were short of luxury, and the longitudinal seating in the center section made room for additional standees. These cars served the URR well for three decades. (Courtesy of the late Charles A. Smallwood.)

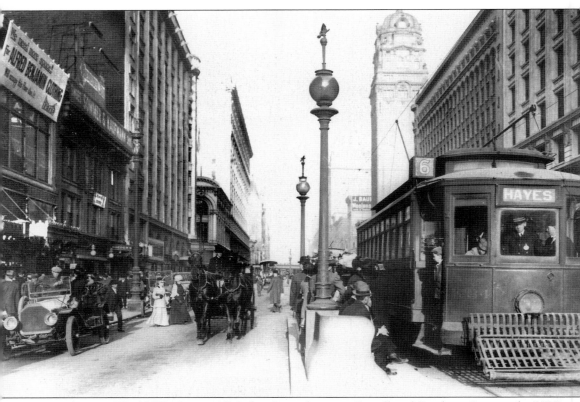

In this pre–World War I view of Market Street between Powell and Stockton Streets, the URR streecar has the street all to itself and there aren't enough automobiles to cause a problem. Some people of means, however, continued to use horsedrawn carriages with top-hatted drivers.

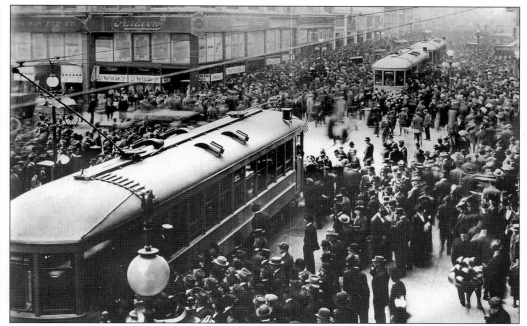

On December 28, 1912, San Francisco became the first city in America to establish a municipal railway, with the intention to bring all of the city's public utilities under public ownership. Today the Municipal Railway is simply called Muni.

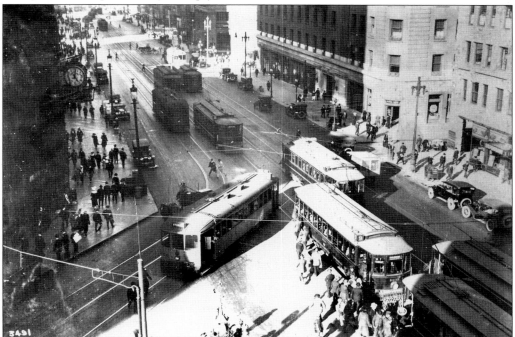

By 1915 the Municipal Railway extended its Geary Street Line into Market Street to go to the Ferry Building. Within a few years there would be four tracks on Market all the way to Castro Street. (Courtesy of City and County of San Francisco, Bureau of Engineering.)

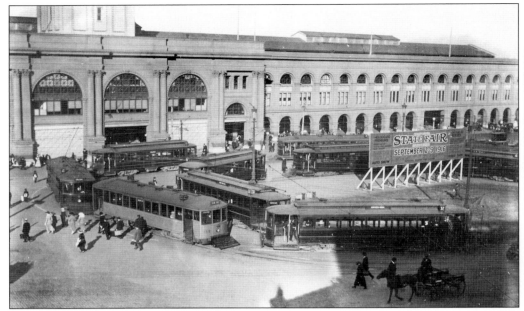

To get to the state fair in Sacramento from San Francisco in 1915, one took a streetcar or cable car to the Ferry Building, boarded a Southern Pacific ferry to Oakland and rode it to Sacramento. Or one could take a Key System ferry to Oakland and ride the electric interurbans of the Oakland, Antioch & Eastern to the state capital. (Courtesy of City and County of San Francisco, Bureau of Engineering.)

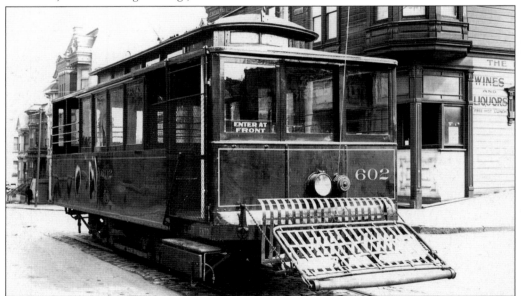

The URR tried to cut expenses on lightly patronized lines by enclosing nine of their single truck cars and making them one-man, eliminating the conductor. However, a disastrous accident caused the city to enact an ordinance requiring two-man cars. The URR stationed the conductor next to the motorman and the cars continued in service into the 1930s. (Courtesy of the late Charles A. Smallwood.)

Three
THE MUNICIPAL RAILWAY

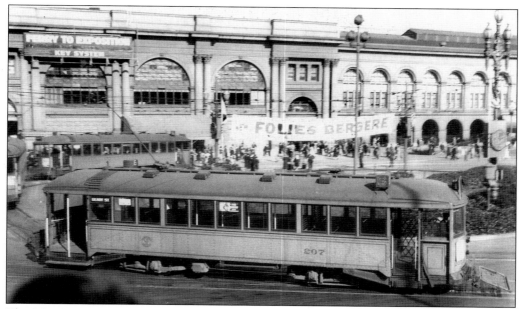

The Muni's cars were strictly no-frills: big, rugged, wood seats, battleship gray with tile-red roofs, and gold trim—and a nickel a ride! In this 1939 view, No. 207 is on the B-Geary Line and has deposited passengers for the Key System's ferries to Treasure Island and the World's Fair.

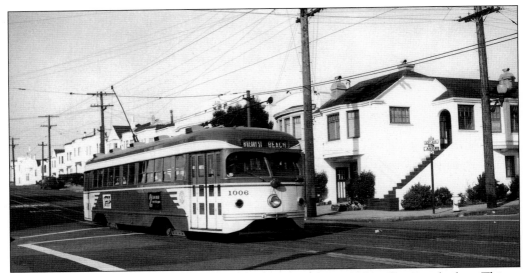

Working the B-Geary Line to the beach, modern PCC No. 1006 is photographed on Thirty-third Avenue while crossing Anza Street in 1949. Originally a two-man car, 1006 was later converted to a one-man car, one of a group known to Muni people as "torpedoes."

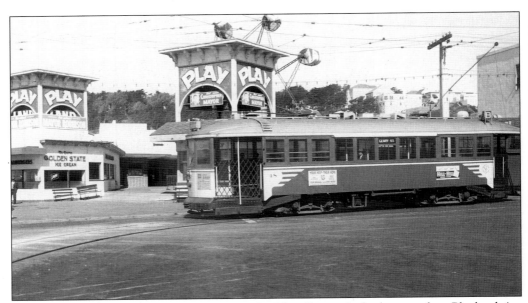

At the outer terminal for the B-Geary Line, Car No. 48 rounds the loop track at Playland-At-The-Beach. Apparently it's a weekday and not in summer, for there are no crowds and the place is litter-free. (Photo by Tom Gray.)

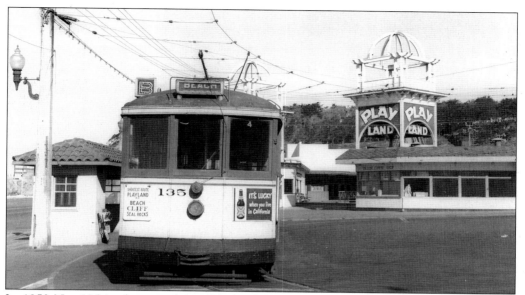

In 1950 No. 135 is about to depart Playland for downtown. While there appear to be few passengers, there will be plenty more before the streetcar reaches the East Bay Terminal, 7 miles and 41 minutes away.

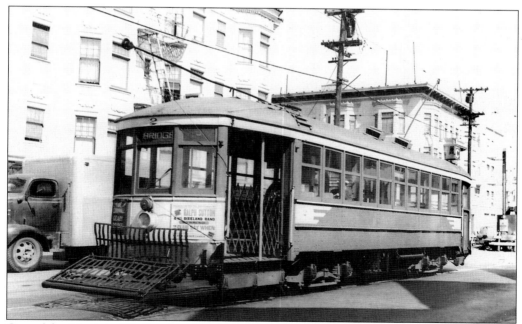

One of the Municipal Railway's original cars, No. 2, is working the C Line, which by 1950 was an abbreviated version of the B Line, running to Second Avenue and then two blocks to Cornwall Street. Car No. 2 was scrapped in 1951 after 39 years of service.

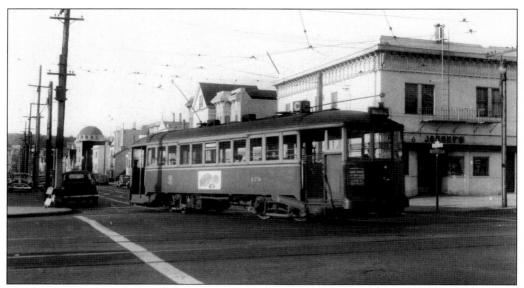

Turning from Second Avenue into Geary Boulevard, No. 129 is on the C Line, heading inbound for downtown in 1950. The C Line had only six years of life left when this photo was taken.

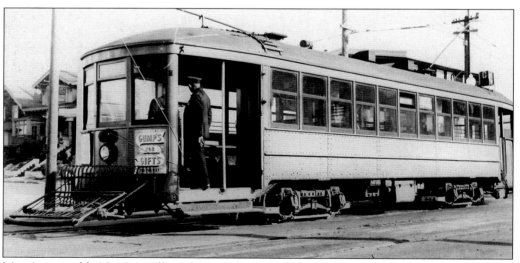

Muni's venerable No. 1 is still on the active roster of historic cars, but once upon a time it was an everyday workhorse, bringing people to work, to shop, to worship, to visit, and just to get around town.

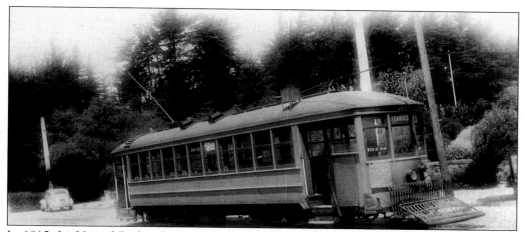

In 1915 the United Railroads' franchise on California Street between Sixth and Thirty-third Avenue expired and was absorbed by the Muni into the C-Geary & California Line. In this view No. 16 is at Thirty-third, next to Lincoln Park and ready to return to downtown.

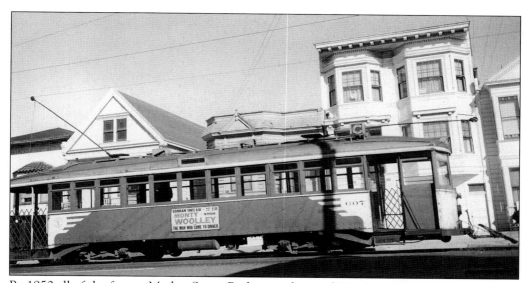

By 1950 all of the former Market Street Railway and several Municipal Railway streetcar lines had been changed to buses and No. 607 was on borrowed time after rolling on San Francisco's streets for 37 years.

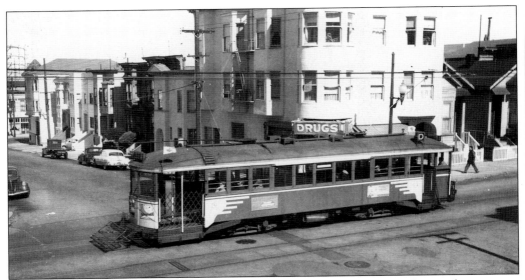

Muni's D-Geary & Van Ness Line ran along its namesake streets to Union Street, then west on Union as shown here at Union and Buchanan Streets in 1948. The D Line was originally built to service the Panama-Pacific International Exposition in 1915.

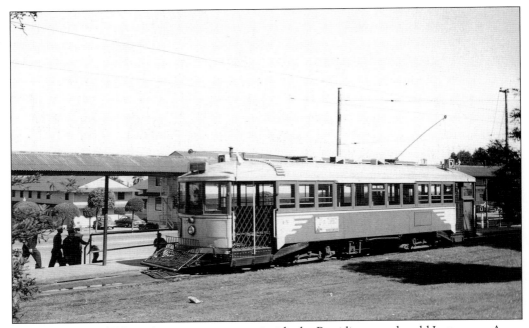

The Muni's D and E Lines' outer terminus was inside the Presidio, near the old Letterman Army Hospital, and provided good access to downtown for soldiers and access to the Presidio's jobs for civilians. The date of this photo is November 11, 1950.

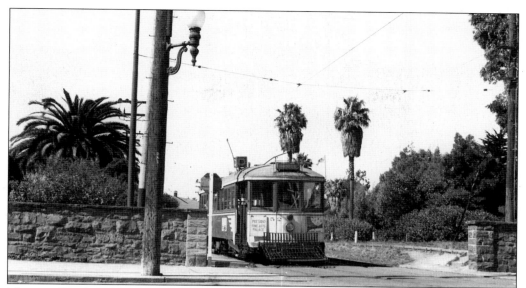

Municipal Railway No. 80 is exiting the Presidio into Greenwich Street at Lyon Street in 1949. Today the gap in the wall is closed and there is little trace of the streetcar line.

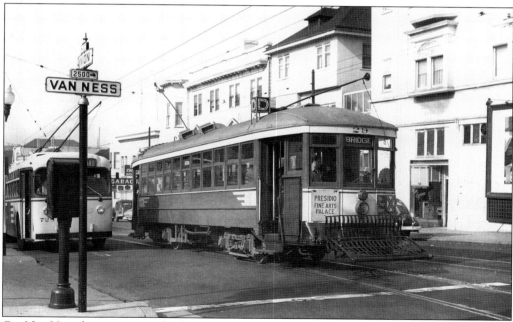

Car No. 29 is about to turn right from Union Street into Van Ness Avenue. It's either late 1949 or early 1950, judging by Marmon-Herrington trolley coach No. 725. The D Line was replaced by buses on March 18, 1950. The streetcar went for scrap in 1951 while the trolley coach was sold in 1978 and went on to a second career in Mexico City. (Photo by Tom Gray.)

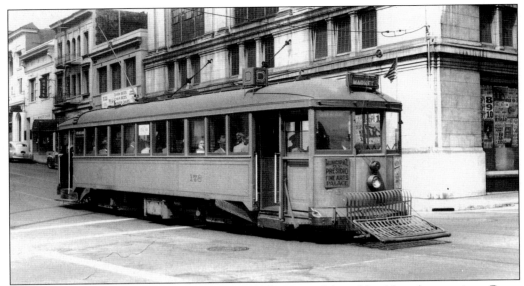

Inbound to downtown on the D Line, No. 178 has turned from Van Ness Avenue into Geary Street and is now at Geary and Polk Streets. Today No. 178 is preserved at the Western Railway Museum in Solano County, California, for the public to ride once again.

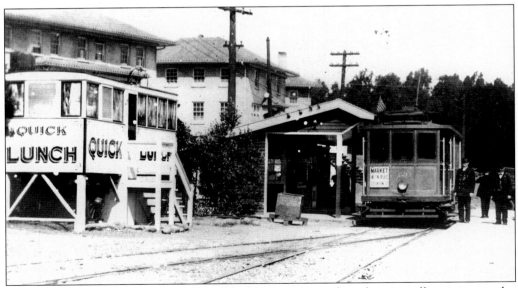

By 1910 the Presidio & Ferries Railroad had been converted to electric trolley, using surplus second-hand cars from the United Railroads. It appears that yet another surplus car is now a diner. In 1913 the P&F will become the Muni's E-Union Line.

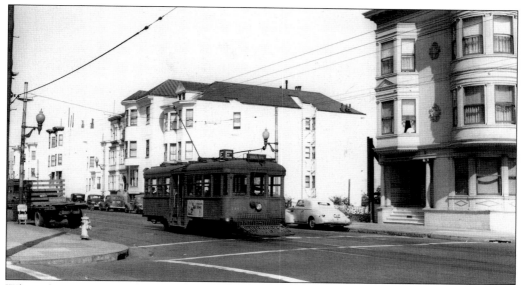

When the Presidio & Ferries Railroad franchise expired, the Muni took over the line and in 1920 replaced the 25-year-old wooden cars with these single-truck, steel cars for the E-Union Line. Here No. 365 is working the E Line in 1947, headed for the Ferry Building.

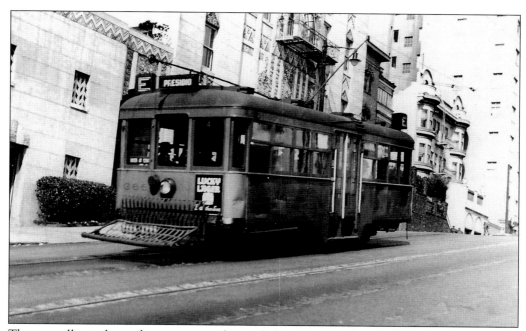

These small, single-truck cars were tailor-made for the E Line to handle the dips in street trackage. Their center entrances made for quick loading and unloading, but required a two-man crew. Here No. 366 is outbound on Union Street.

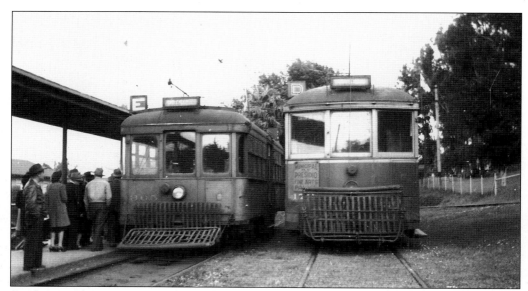

Civilians at the Army's post, known since Spanish colonial days as the Presidio, gather at the Presidio Loop to board either the Muni E-Union or D-Geary & Van Ness Lines in 1946.

No. 357 on the E-Union Line lays over at the Ferry Building. Rather box-like in appearance, the "dinkys" of the Union Street were nevertheless utilitarian and were sometimes used as shuttle cars on new lines until they had built up business.

The impetus for building the F-Stockton Line was the Panama-Pacific International Exposition in the Marina District in 1915, bringing patrons from Stockton and Market Streets through the Stockton Street Tunnel to Columbus Avenue, then west on Chestnut Street to Scott Street. This meant sharing the street with the Powell & Mason cable cars for a short distance, but they managed to co-exist.

Not until 1947 would the Muni be able to fulfill a 1915 promise to bring the F Line to the Southern Pacific Depot at Third and Townsend Streets, as shown here. The streetcars were gone a mere four years later, replaced by buses.

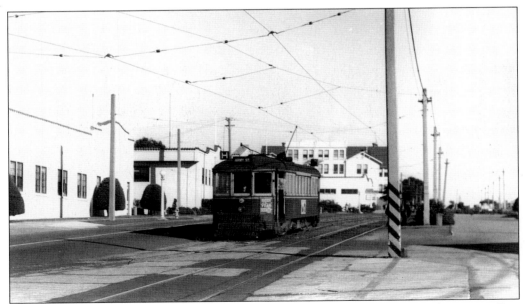

The H-Potrero Line traveled north-south on Van Ness and Potrero Avenues and went into Fort Mason, a disembarkment center for the Army troopships to the Pacific.

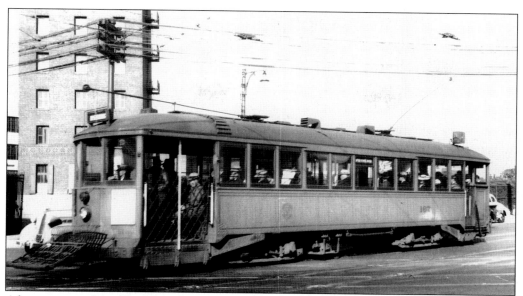

After going south on Van Ness Avenue, the H Line turned up at Eleventh and Division Streets before going out Potrero Avenue to Army (now Cesar Chavez) Street in the Mission District.

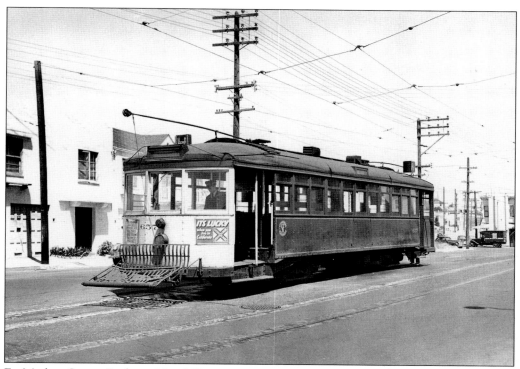

Ex-Market Street Railway No. 257, now Muni 657, is on the H Line at San Bruno and Campbell Avenues—former MSR trackage!—on July 1, 1949. In two more days the H Line would revert to its original outer terminus at Potrero and Army Streets.

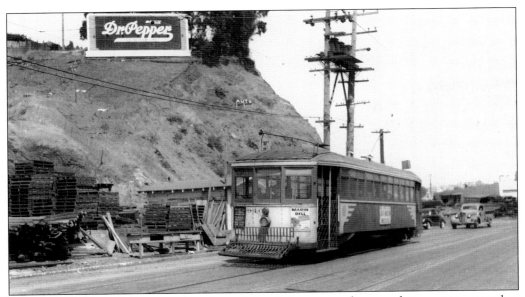

The post-war period saw many reroutings of the city's streetcar lines, and it was not unusual to see Muni cars on ex-MSR rails and vice versa. In 1947 the H Line was extended from Army Street and Potrero Avenue to Bayshore Boulevard and San Bruno Avenue.

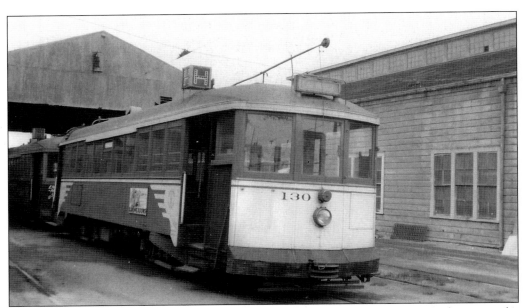

In an odd setting, Muni No. 130, signed for the H-Potrero, is resting at Sutro Carhouse, a relic of the Sutro Railroad from 1896. In the late 1950s, No. 130 became a wrecker car and in 1982 was restored to blue and gold colors to join the historic trolley fleet.

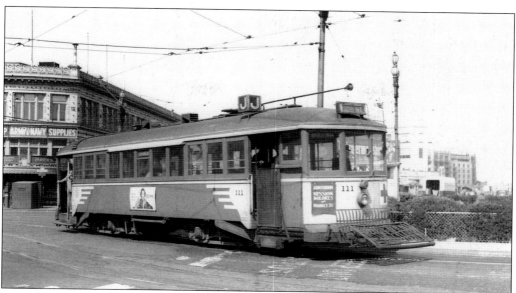

No. 111 on the J-Church Line enters the Ferry Building Loop in 1949, one of the few streetcars still using the 43-year-old trackage. The lack of passengers truly indicates changing times.

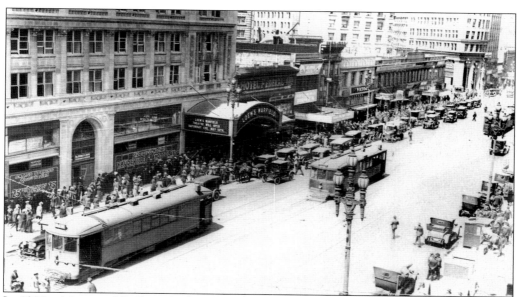

In 1922 a Municipal Railway J-Church car rolls out Market Street past the Loew's Warfield Theater on its way to Church Street. The United Railroads tried everything from persuasion to negotiation to the courts to stop Muni's encroachment, all to no avail, and the proliferation of flivvers prefigure a planner's nightmare.

The Municipal Railway's J-Church Line served not only the largely residential Mission District and downtown, but also Mission High School in the background. (Photo by Tom Gray.)

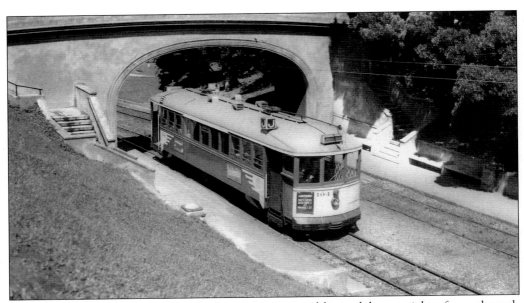

The J-Church Line owes its continued existence as a rail line solely to a right-of-way through Dolores Park, bypassing the steep grade on Church Street. This scenic line is a mecca for railfans even today.

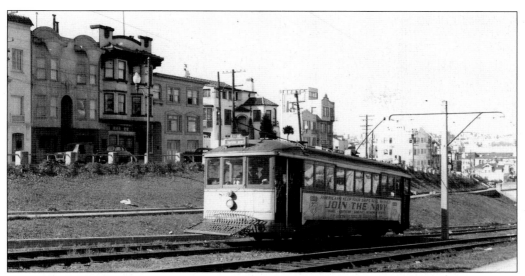

Although World War II had been over for two years, Muni's No. 86 was still recruiting for the war effort on the J-Church Line.

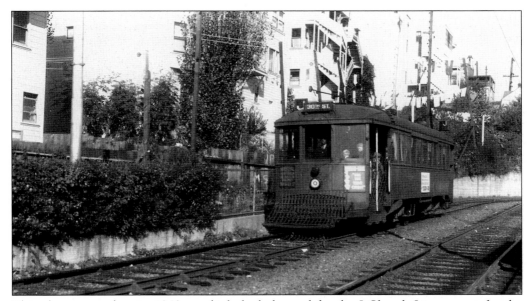

This photo was taken in 1940, yet little had changed for the J-Church Line except for the rolling stock: Since 1981 the line has been served by Light Rail Vehicles (LRV) instead of trolley cars.

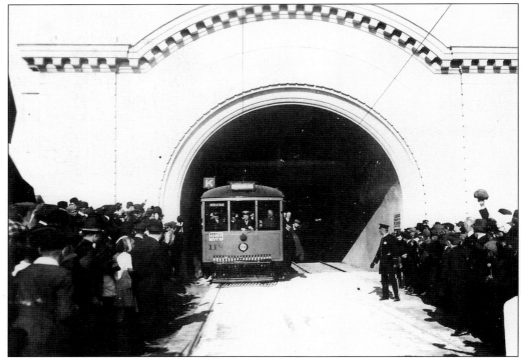

On February 3, 1918, Mayor James "Sunny Jim" Rolph was the motorman on the first streetcar through the Twin Peaks Tunnel on the K-Ingleside Line. The Muni was Sunny Jim's pride and joy, and he was always there for an opening—usually as the motorman.

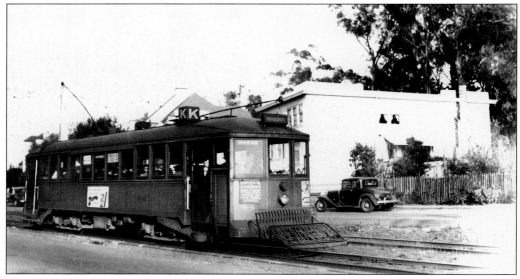

The K-Ingleside Line went from Market Street through the Twin Peaks Tunnel to West Portal, then southwest on West Portal Avenue to St. Francis Circle, Junipero Serra Boulevard to Ocean Avenue, and Ocean to Brighton and Grafton Avenue.

Back then, building transportation systems came first, *then* development, as this view of almost rural St. Francis Circle and a lonely K-Ingleside streetcar testifies.

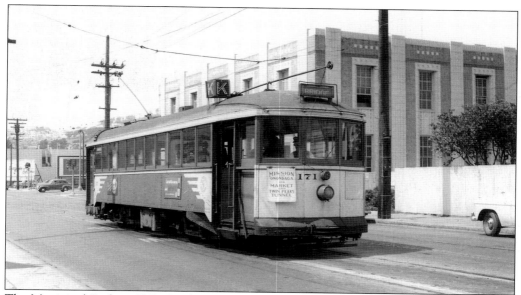

The Municipal Railway K-Ingleside Line has shifted its outer terminals several times over the years. In 1947 when this photo was taken, it was at Mission Street and Onondaga Avenue.

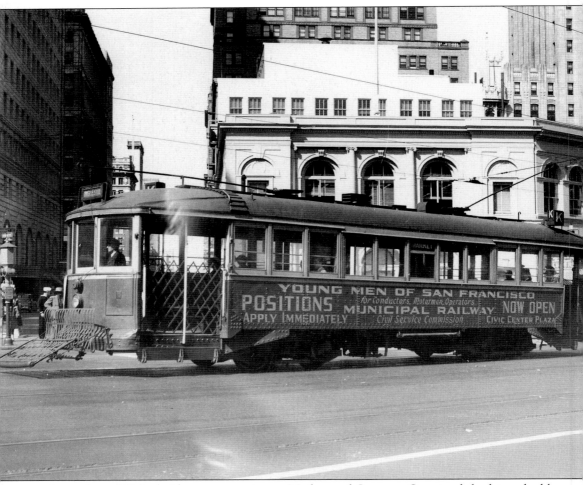

An outbound K-Ingleside streetcar stops at Market and Sansome Streets while doing double duty: transporting San Franciscans and advertising for platform personnel during World War II manpower shortages. At this time women first went to work on the city's streetcars.

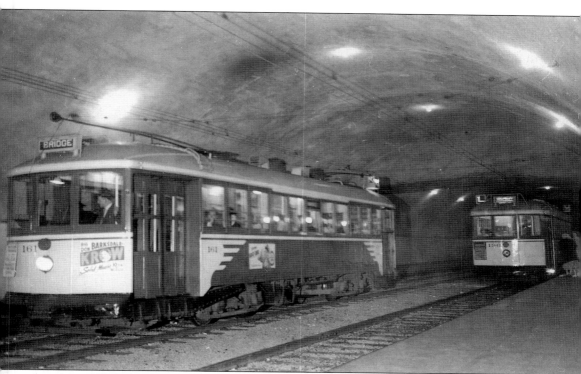

An inbound K-Ingleside car and an L-Taraval car pass each other at Laguna Honda Station in the Twin Peaks Tunnel on June 22, 1951. The Twin Peaks Tunnel, built between 1916 and 1918, is 12,000 feet long and cost $4.5 million—a considerable sum in those days. The project was financed largely by forming a special tax assessment district.

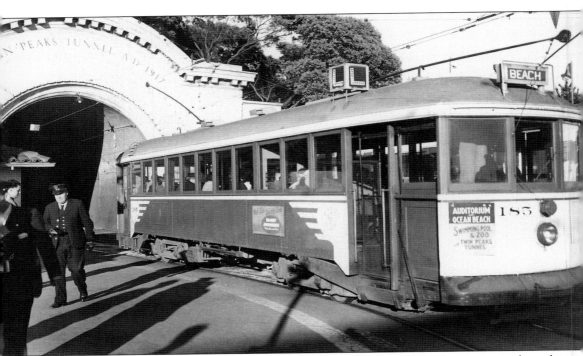

On September 11, 1950, streetcar No. 185 stopped at West Portal after having gone through the tunnel from Market Street on the L-Taraval Line. Next the car will turn right into Ulloa Street, then west on Taraval Street to go to the Zoo.

Muni's No. 1003 was one of five modern cars purchased in 1939. In 1956 the car is on the L-Taraval Line on Taraval Street at Twentieth Avenue. Today No. 1003 is preserved at the Western Railway Museum in Solano County, California, in active service.

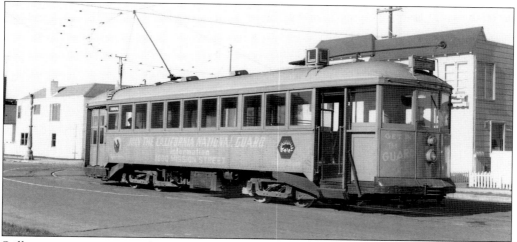

Still sporting its wartime advertising to join the California National Guard, a Muni car on the L-Taraval Line lays over at Forty-seventh Avenue and Wawona Street, a block away from the zoo, in 1947.

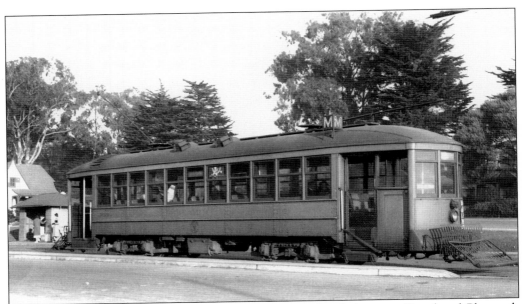

In its early years, the M-Ocean View Line was only a shuttle between Broad and Plymouth Avenues and St. Francis Circle, due to a lack of population in that part of the city to justify a streetcar line all the way to the Ferry Building. The year is 1940.

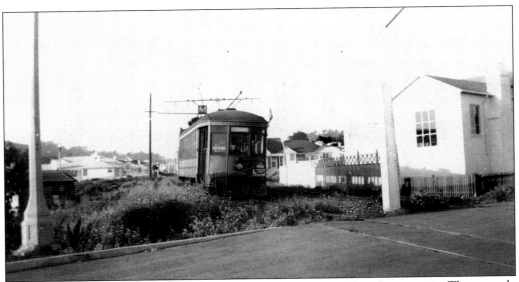

If ever a streetcar line was built for the future, the M-Ocean View Line was it. The sparsely populated area shown here was to see home construction boom in post-war years, spurred in large part by the G.I. Bill. Today the line also serves San Francisco State University, and the LRVs are usually crowded.

Four

THE UNITED RAILROADS
AND THE
MARKET STREET RAILWAY

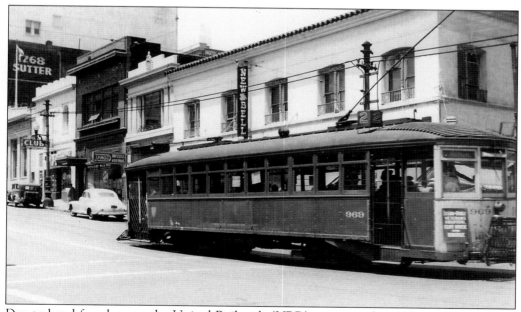

Due to bond foreclosures, the United Railroads (URR) reorganized in 1921, again becoming Market Street Railway (MSR). There was little change, except repainting the cars with white fronts, as shown by No. 969 on Sutter Street. In 1944 the bankrupt MSR was sold to the city.

Outbound to Sutro's on the 1 Cliff Line meant riding over a private right-of-way to Land's End and Sutro's with scenery so spectacular that one forgets that in this relatively small land area

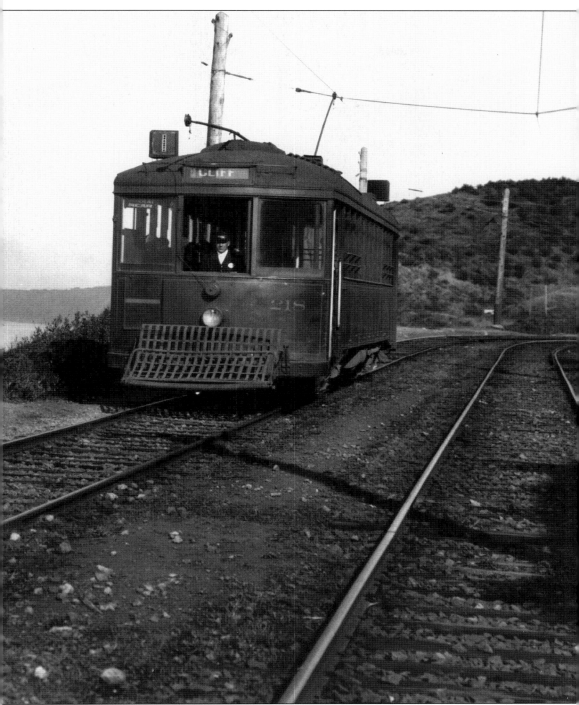

were also had factories, warehouses, and a downtown. (Courtesy of the late Charles A. Smallwood.)

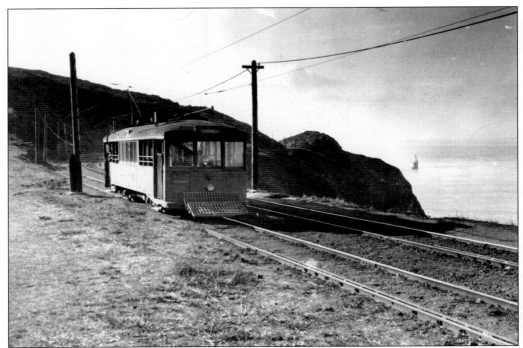

Once called the most beautiful streetcar line in the world, this was the URR's 1 Line. Unfortunately, there was a washout in 1925 that put the line out of business, about where this picture was made. Today this is an urban hiking trail. (Courtesy of the late Charles A. Smallwood.)

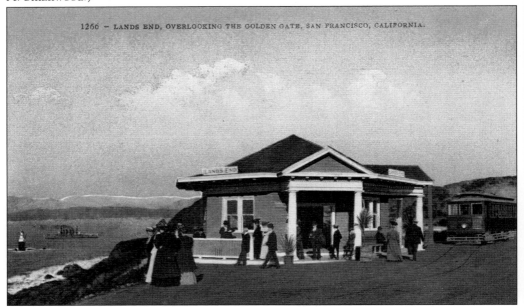

1266 — LANDS END, OVERLOOKING THE GOLDEN GATE, SAN FRANCISCO, CALIFORNIA.

At Land's End patrons could get off the streetcars to admire the fabulous view of the Golden Gate and then take a leisurely stroll downhill to Mayor Adolph Sutro's recreation complex or the Cliff House. This was affordable recreation for the city's blue collar workforce before World War I.

Painted green with white trim, Sutro Station hosted both the 1 Sutter & California and the 2 Sutter & Clement Lines of the MSR. A relic of the Sutro Railroad, the wooden structure was lost to a fire on February 12, 1949. (Courtesy of Raymond Muther.)

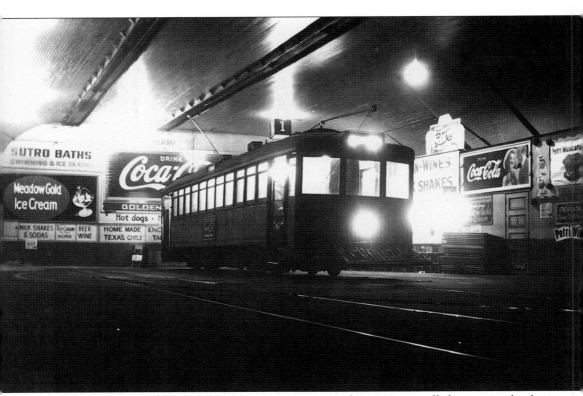

Inside the cavernous Sutro Station were streetcars to bring patrons all the way to the ferries, plenty of advertising, and the aromas of roasting peanuts, popcorn, hot dogs, hamburgers, and salt air from the sea. (Courtesy of Raymond Muther.)

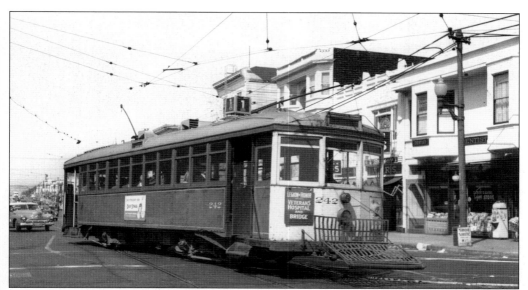

No. 242 of the 1 Line switches off Clement Street north into Sixth Avenue in the city's Richmond District on its way downtown and the East Bay Terminal in 1947. These building all stand today, albeit much remodeled.

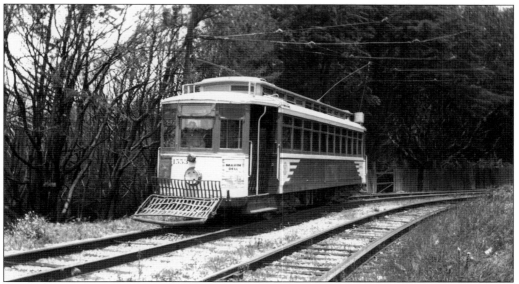

Occasionally the MSR's 1 Line was routed over the 2 Line's right-of-way into Sutro Station. In this bucolic view, Car 1533—by now a city property and in Muni livery—is rounding a curve en route to Sutro's.

Outbound No. 215 on the 4 Line turns off Sutter into Fillmore Street. At Sacramento Street, the car will again turn west, across Arguello Boulevard into Lake Street. While unmistakably a MSR car, the year is 1947 and the line is part of the Municipal Railway. (Photo by Tom Gray.)

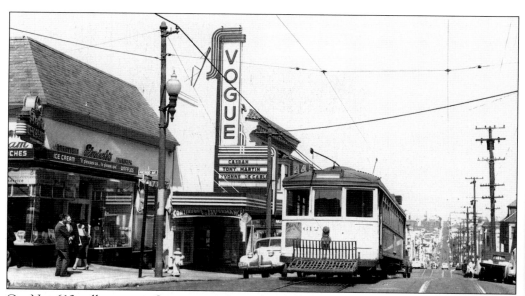

Car No. 612 rolls west on Sacramento Street on the 4 Line, stopping at Presidio Avenue in front of the Vogue Theater. Since 1866 Sutter Street lines have been horsecars, steam trains (for only a brief time), cable cars, streetcars, motor buses, and trolley buses.

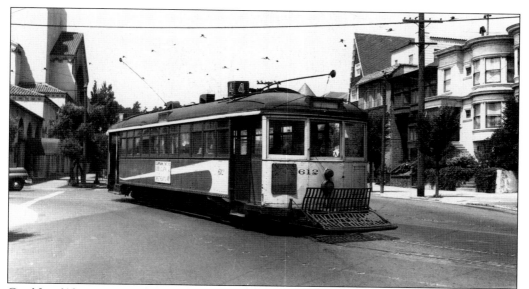

Car No. 612 is now returning to downtown and is making the curve from Lake Street into Arguello Boulevard and immediately into Sacramento Street. The building at left is Temple Emanu-El. (Photo by Tom Gray.)

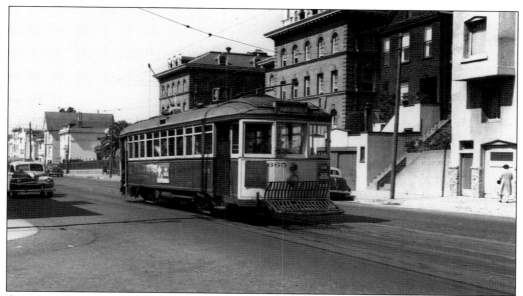

Car No. 665 is photographed going inbound on the 4 Line in 1948. The scene is Lake Street at Fourth Avenue and the line is now part of the Municipal Railway. (Photo by Tom Gray.)

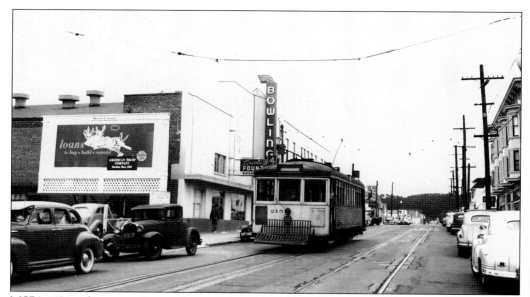

MSR's 4 Line became a Sutter Street line in 1935. Here No. 215 is inbound on Sixth Avenue between Clement Street and Geary Boulevard, passing the Lincoln Bowl. The year is 1948 and on July 31 this would become a bus route. (Photo by Tom Gray.)

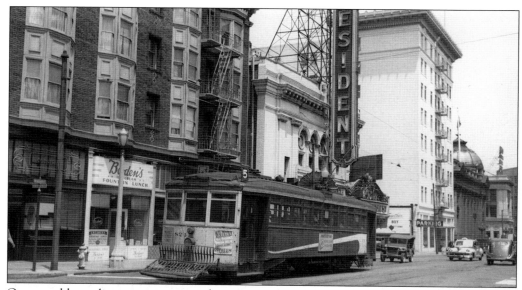

Once a cable car line, now a streetcar line, soon to be a motor bus, and then a trolley coach line, Car No. 824 has just turned off Market Street into McAllister Street. The dome in the right background is the Hibernia Bank Building.

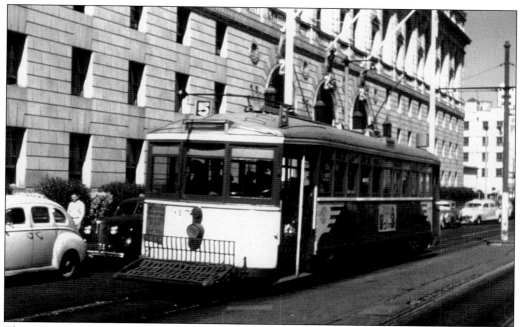

The 5 Line passes through the city's Civic Center, a cluster of public buildings covering ten city blocks. Former MSR No. 915 passes the State Building en route to Playland-At-The-Beach. (Photo by Robert McVay.)

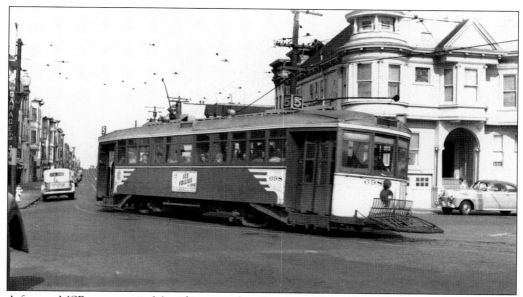

A former MSR car, now in Muni livery, makes the turn off McAllister Street on the 5 Line into McAllister Carhouse to cut diagonally across a city block to Fulton Street.

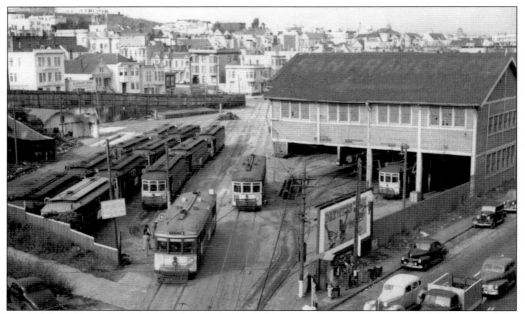

McAllister Carhouse, built in 1883 for cable cars, was converted in 1906–1907 to a streetcar facility, retaining the unique feature of diagonal tracks cutting through the yard to connect McAllister and Fulton Streets. For most streetcar riders, this was their only glimpse of a carhouse; for railfans it was paradise! (Courtesy of Emeliano Echevarria.)

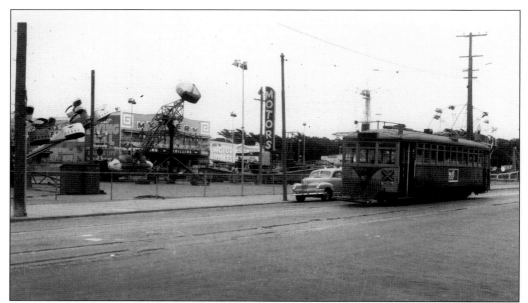

The 5 Line went north off Fulton Street into La Playa and terminated two blocks later at Balboa Street, bringing thousands of riders over the years to the amusement park called Playland-At-The-Beach. Car 845 is wearing one of several paint schemes adopted after MSR's merger with the Muni in 1944.

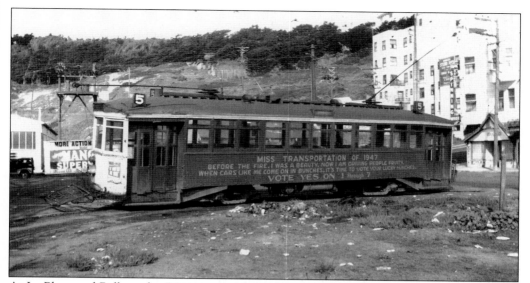

At La Playa and Balboa, the 5 Line turned into a loop to reverse direction. In this 1947 photo, the city has painted advertising on the car urging a "Yes" vote for bonds which, ironically, will be used to finance conversion of this streetcar line into a bus line. (Photo by Tom Gray.)

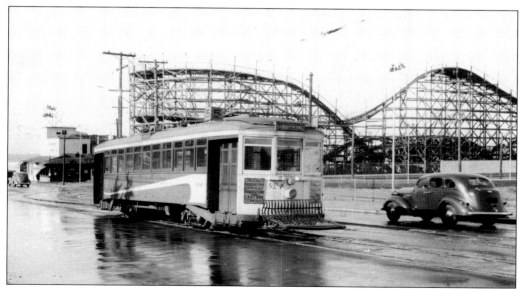

MSR car No. 824 has just re-entered Fulton Street on its jaunt back to downtown and the East Bay Terminal. In the background is the Big Dipper, a rickety old wooden roller coaster and one of Playland's—and the 5 Line's—biggest attractions.

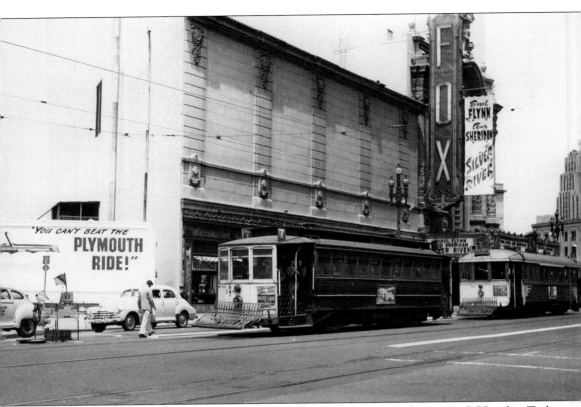

The Market Street Railway's 7-Haight Line went from the bay to the ocean, 7.75 miles. Today the streetcars are gone, the Fox Theater is gone, and the 36-story Russ Building (right background) is no longer the city's tallest building. (Photo by Tom Gray.)

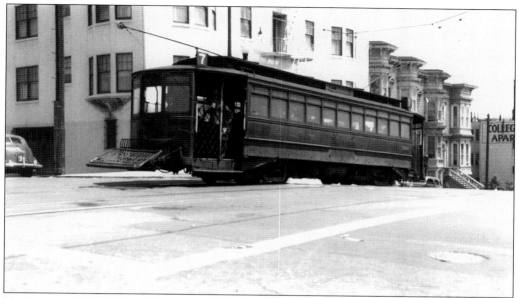

Having turned off Market Street into Haight Street, No. 169 is traveling the length of Haight towards Golden Gate Park in 1947.

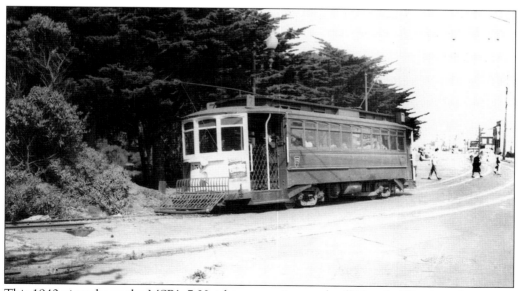

This 1940 view shows the MSR's 7-Haight car turning north off Lincoln Way into the private right-of-way through Golden Gate Park. The 7 Line was a combination of the Park & Ocean Railroad and the Haight Street cable car line.

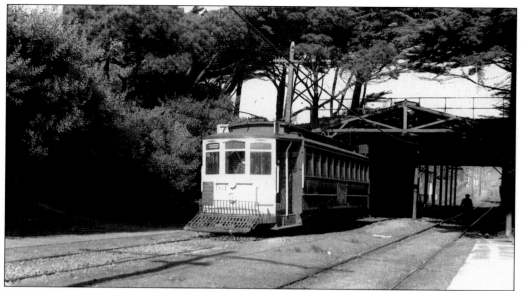

In this photo, MSR No. 161 has just passed through the tunnel under Golden Gate Park's Main (now John F. Kennedy) Drive on its outbound trip to Playland, where it shared the loop with the 5 Line. (Photo by Tom Gray.)

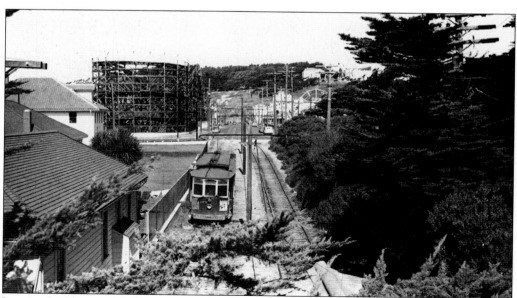

Leaving La Playa and Balboa Street, the 7-Haight Line has crossed Fulton Street and entered its private right-of-way in Golden Gate Park en route to downtown.

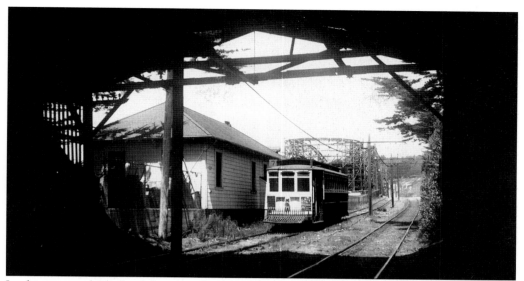

Looking toward Playland from inside the streetcar tunnel. In spite of repeated demands by planners for a full bore tunnel under Golden Gate Park, this remained the closest they would ever get.

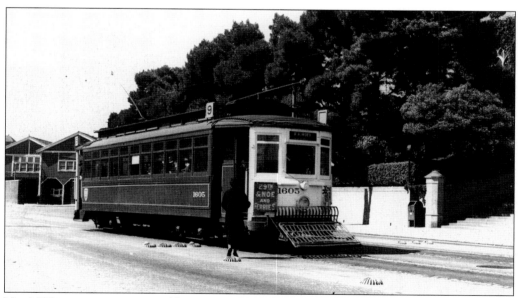

No. 1605 is on its way to one of four outer terminals used by the 9-Valencia Line, Twenty-ninth and Noe Streets. In the background is the Twenty-eighth & Valencia Carhouse, which housed the United Railroads' carshops before 1907.

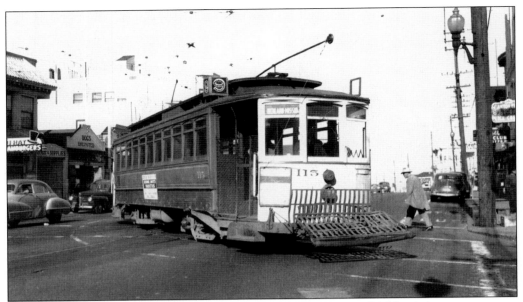

In this 1948 photo, Car No. 115 turns off Mission Street into Richland Avenue to go to Andover Street, one of four Mission District terminals for the 9 Line over the years.

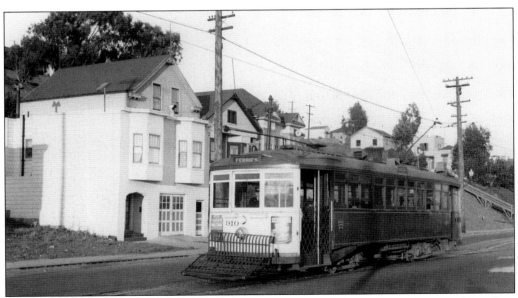

Car No. 910 is working the MSR's 10 Line on Sunnyside Avenue (now Monterey Boulevard) in 1940. This line also began at the Ferry Building, went out Mission Street, and turned off on Sunnyside to Genessee Street near Westwood Park.

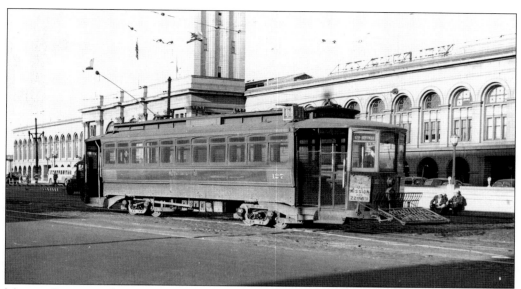

Mission Street was home to four streetcar lines and the interurban line to San Mateo. One of the Mission Street lines was the 11-Hoffman Avenue Line, which began at the Ferry Building.

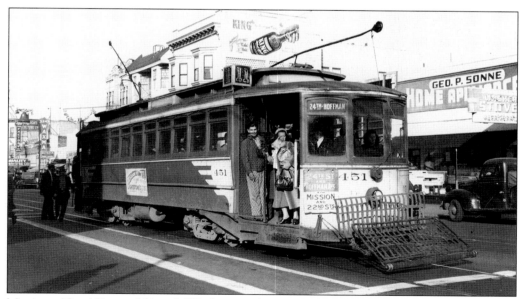

Muni car No. 451 was 151 in MSR days; in this 1948 photo, the car works the 11-Hoffman Line, stopping at Mission and Twenty-one Streets on its way to Twenty-fourth Street and Hoffman Avenue.

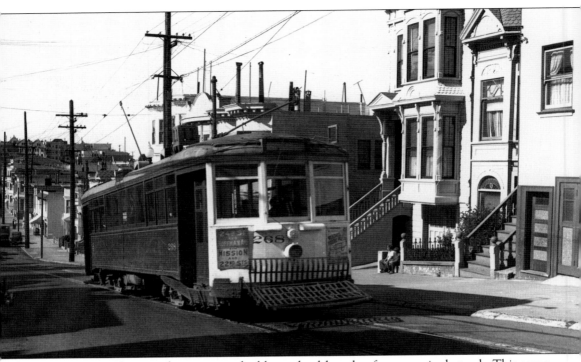

Most streetcar lines in the city were double track, although a few were single track. This scene on Chattanooga Street on the 11-Hoffman Line was one of them.

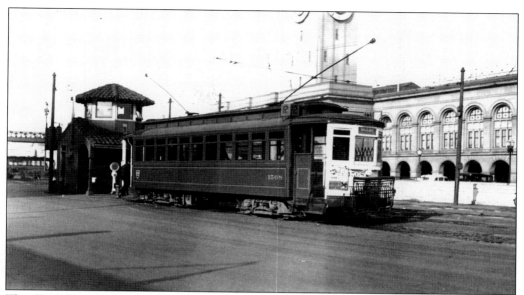

The City's longest streetcar line was the 12-Mission & Ingleside, at 10 miles, beginning at the Ferry Building. The eight lines operating south of Market Street terminated on stub tracks next to the loops for the Market Street lines.

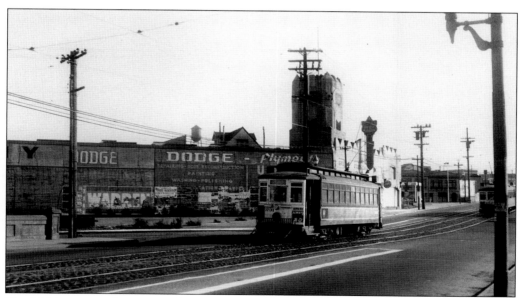

The 12 Line covered a variety of scenes, ranging from downtown to the wide open tracks along Sloat Boulevard. Here car No. 1731 is on Mission Street at Alemany Boulevard in the Outer Mission District.

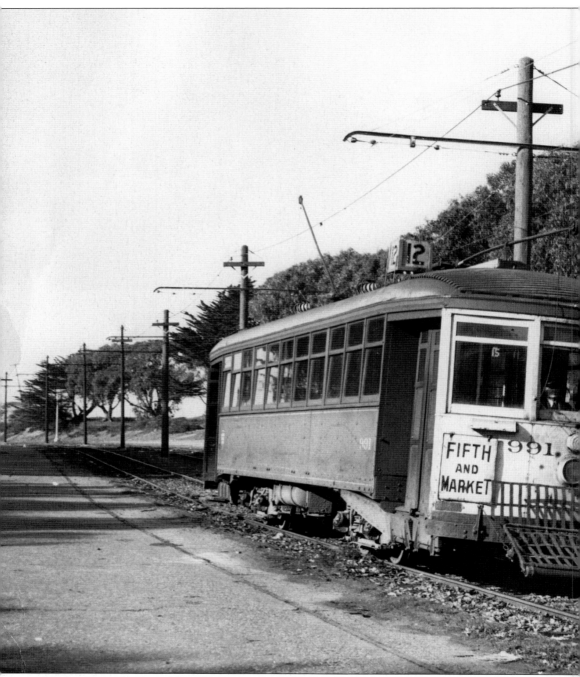

Market Street Railway No. 991 returns from the zoo along Sloat Boulevard while working the 12 Line. It's unusual for a 12 Line car to be signed for Fifth and Mission Streets; perhaps it was

a Sunday or a holiday. This was the fourth from the last car to have been built by the MSR. It was outshopped in 1933 and retired in 1949.

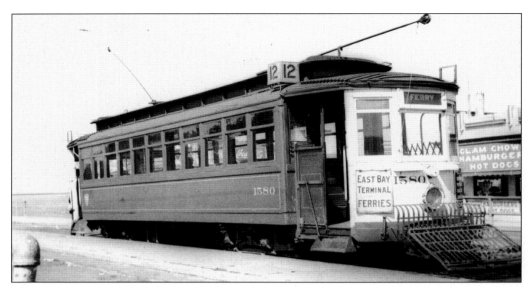

The western terminus of the 12 Line was about a city block away from the shoreline of the Pacific Ocean, across from Fleishacker Zoo, Fleishacker Playground, and Fleishacker Pool, referred to by San Franciscans simply as "Fleishacker's."

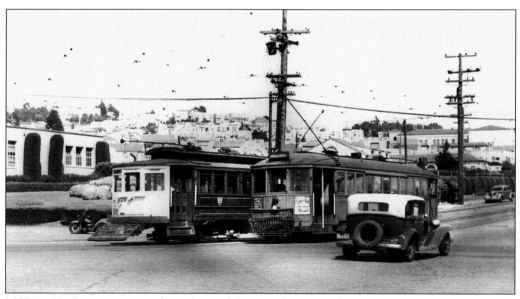

MSR's 12 Line went outbound on Mission Street and Ocean Avenue to Junipero Serra Boulevard to Sloat Boulevard. The Muni's K Line went outbound on Market Street, through the Twin Peaks Tunnel to West Portal Avenue to Junipero Serra, then east on Ocean Avenue. Thus the anomaly of two outbound cars in opposite directions. (Courtesy of the late Charles A. Smallwood.)

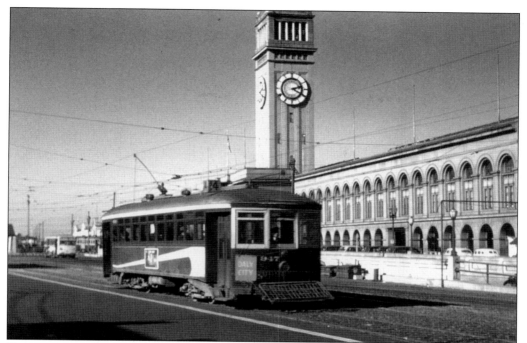

Here is a 14-Mission car at the Ferries. After the 1944 takeover of the MSR, the Muni was forced to remove the patented white front, resulting in many color combinations. No. 947 has a blue and gold front but keeps MSR colors on the sides and roof. (Photo by Robert McVay.)

MSR No. 949 rumbles eastward on Mission between Seventh and Sixth Streets. The U.S. Courthouse is at the left. In the Gold Rush era, the area in the left foreground was a lagoon and the street was a plank road. (Courtesy of City and County of San Francisco, Bureau of Engineering.)

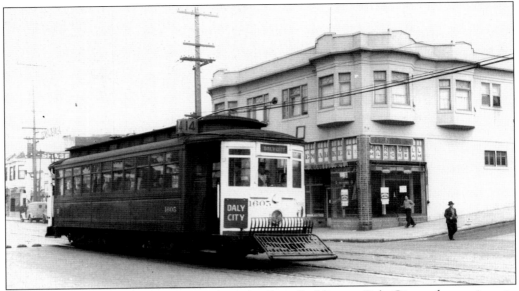

The important 14-Mission Line went from the Ferry Building to Daly City and sometimes to Holy Cross Cemetery in Colma, both in neighboring San Mateo County. This car is on Mission at Persia Streets on the edge of the Excelsior District.

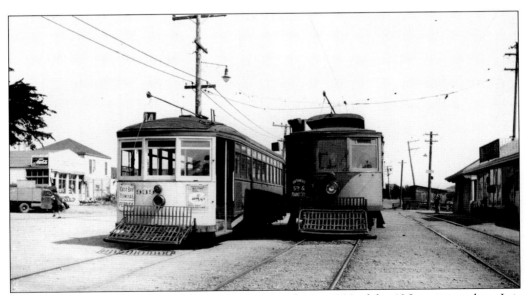

Streetcar 939 is working the 14 Line and has met with No. 1232 of the 40 Line interurban. It is either a Sunday or Memorial Day, because the 14 Line is extended from Daly City to Holy Cross Cemetery in Colma, where this photo was made in 1948. (Photo by Tom Gray.)

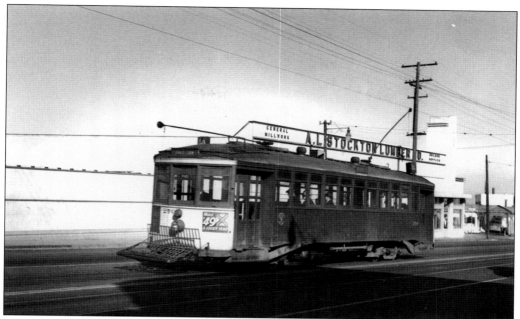

With a 7.75-mile run, the 14-Mission Street Line was one of the city's longest routes. In this 1948 scene, No. 279 is on Mission Street near Sickles Avenue near the county line.

Car No. 944 is going outbound at Third and Berry Streets on the 16-Third & Kearny Line, sporting the MSR's final livery of white front, green sides with white streamstyle flourish, and a yellow roof. The route sign on the roof is yellow with black numerals.

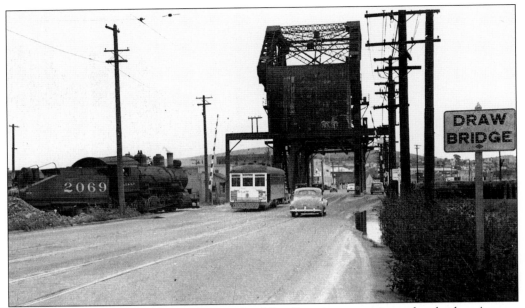

Islais Creek is a slough on the southeast side of San Francisco requiring a drawbridge. As seen here, the bridge hosted both streetcars and steam locomotives in freight switching operations, such as Santa Fe No. 2069.

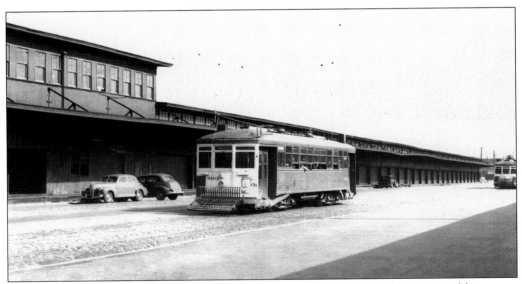

Outer Third Street was given to light industry and warehouses in an area known to old timers as Butchertown, in honor of its origins. An absence of automobiles indicates a need for public transport. In fact, the 16 Line was quite profitable, even with a nickel fare.

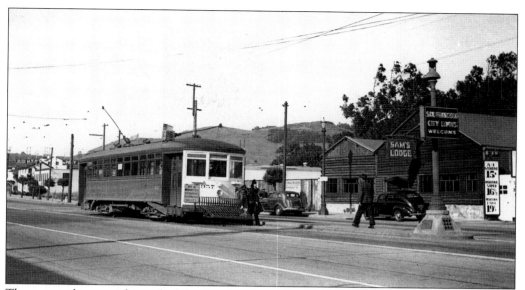

The county line was the end of the line for the 16 Line, as the motorman is about to lift and hook up the eclipse fender. Next he'll change the trolley poles while the conductor moves the farebox to the other end. Then the streetcar will be ready to go back the other way.

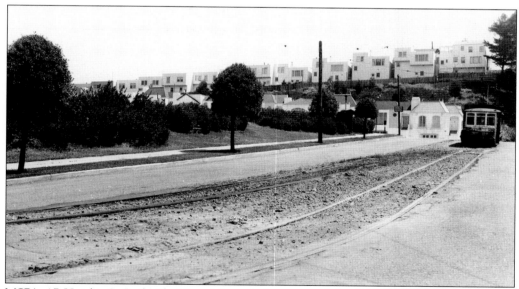

MSR's 17-Haight & Ingleside Line followed the route of the 7-Haight Line to Twentieth Avenue, turned south at Twentieth to Wawona Street, then east on Wawona to the switchback at Nineteenth Avenue in the city's then sparsely-populated Sunset District. (Courtesy of City and County of San Francisco, Bureau of Engineering.)

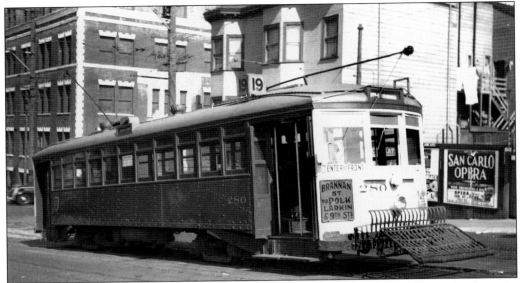

The 19-Polk Line replaced the crosstown cable car line in 1907 and was converted to buses in June 1939, following the courts' upholding the city's two-man streetcar ordinance in February. In 1940 during peak service, some former one-man cars returned. By now the MSR was losing money despite the fare increase to 7¢.

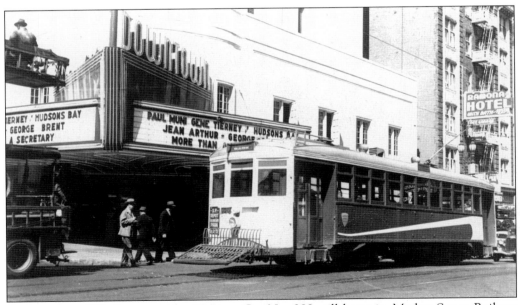

Outbound on Ellis Street on the 20 Line, Car No. 288 still bears its Market Street Railway livery with the white front. Not all former MSR cars were painted in Muni colors before scrapping—there were just too many of them. The 20 Line had its origins in the Metropolitan railway, San Francisco's second trolley line.

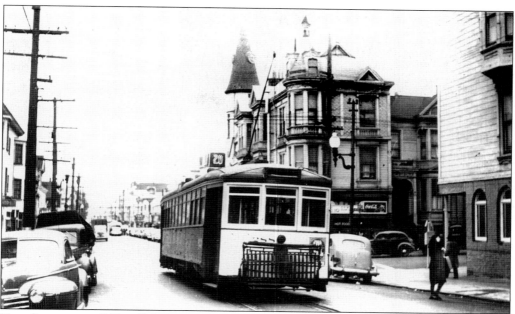

Traveling west on O'Farrell Street, Car No. 288 had just let off a lady at Webster Street in 1945. The ornate wooden buildings were of a style known in San Francisco as "Carpenter's Gothic."

The 20-Ellis & O'Farrell Line had quite a trip, starting at the Southern Pacific Depot at Third and Townsend Streets and ending up at the Stanyan and Haight entrance to Golden Gate Park, as shown here.

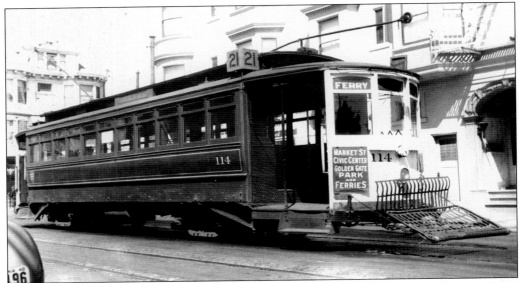

In this 1940 view, MSR No. 114 has reversed ends and is ready to depart from Clement Street and Eighth Avenue for the Ferry Building on the 21-Hayes Line, originally a cable car line.

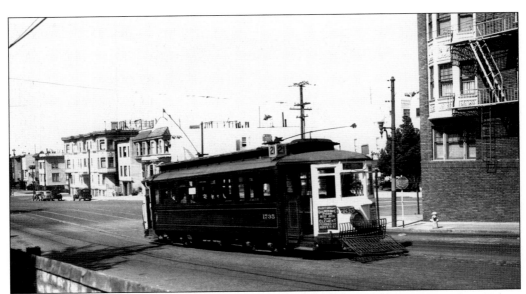

The 21-Hayes Line went on Eighth Avenue from Clement Street to Fulton Street, along Fulton and the north side of Golden Gate Park to Stanyan Street, Stanyan to Hayes Street, Hayes to Market Street and to the ferries. This photo was made from inside the wall of Golden Gate Park near Arguello Boulevard.

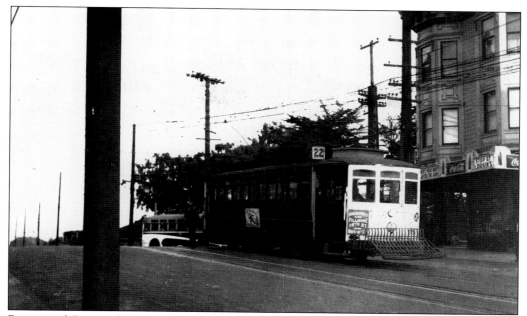

Bryant and Sixteenth Streets was the outer terminus of the 22-Fillmore Line, across from Seals Stadium, home to the city's minor league baseball club. In the background is one of the Market Street Railway's buses.

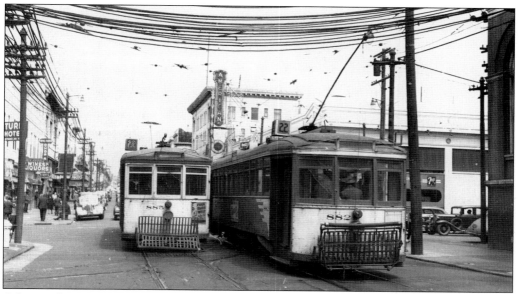

A brace of 22 Line cars pass at the intersection of Turk and Fillmore Streets. The track in the left foreground leads into the Turk & Fillmore Carhouse, while at right is the Turk & Fillmore Substation with its myriad of cables feeding power to overhead trolley wires.

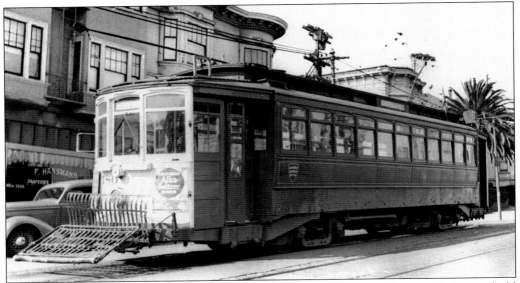

The MSR's 24-Divisadero Line was a chronic money loser, its main function being to hold down a franchise and accept transfers from other lines. In 1939 the two-man streetcars gave way to one-man buses.

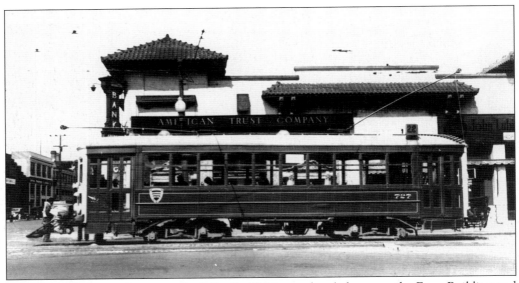

Another MSR money loser was the 1.5-mile 28 Line, a shuttle between the Ferry Building and the Southern Pacific Depot south of Market Street. To save costs, one-man cars were tried, starting in 1935, using second-hand cars from other cities, such as No. 727 from Williamsport, Pennsylvania. No. 727 is on Third at Townsend Streets in 1938, the year the courts upheld the two-man ordinance.

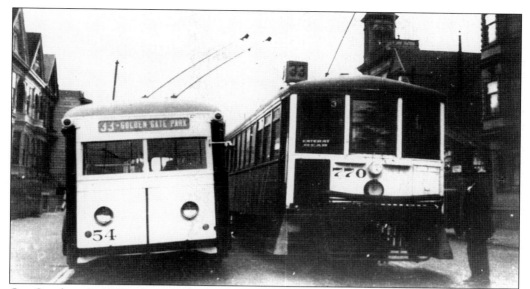

On October 6, 1935, the MSR converted the 33-Eighteenth & Park Line, which was a descendant of the San Francisco & San Mateo Railway, into a trolley coach line. Other than an experimental trolley coach operation in Los Angeles from 1910 to 1915, this was the first trolley coach service west of Salt Lake City, Utah.

Former Market Street Railway No. 970, now a Municipal Railway property, is outbound from Market Street on Eddy Street in the city's Tenderloin in 1948.

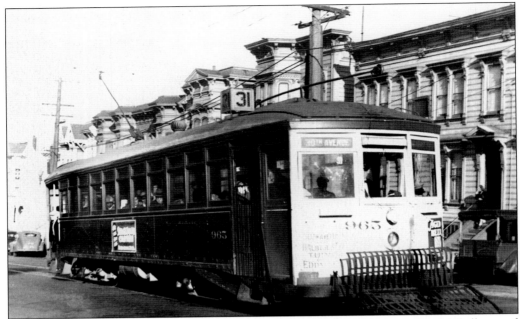

Outbound on Eddy Street in the city's Western Addition, No. 965 is on the 31-Balboa and is representative of some 250 streetcars built new in the MSR's Elkton Shops in the 1920s and 1930s.

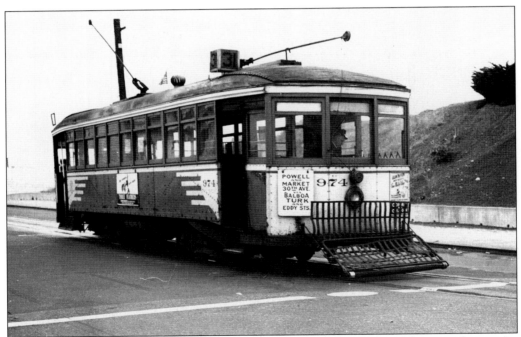

Ex-MSR No. 974, in Muni colors, is posed at Thirtieth Avenue on the 31 Line, ready to make another trip downtown. No. 874 was saved by the Bay Area Electric Railroad Association, but unfortunately was burned by vandals in 1958 before it could attain museum status.

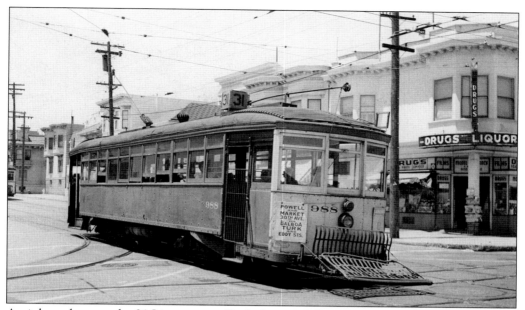

An inbound car on the 31 Line stops at Sixth Avenue. The 31 Line was the last new streetcar line built with private money in San Francisco. Built in 1932, the line gained much good will for providing needed jobs during the Great Depression.

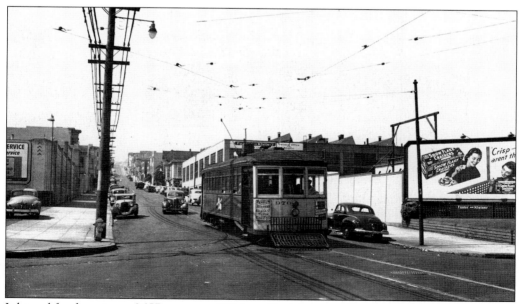

Inbound for downtown, MSR streetcar 976 is on Turk between Pierce and Steiner Streets. The spur track leading into Steiner goes to the Turk & Fillmore Carhouse.

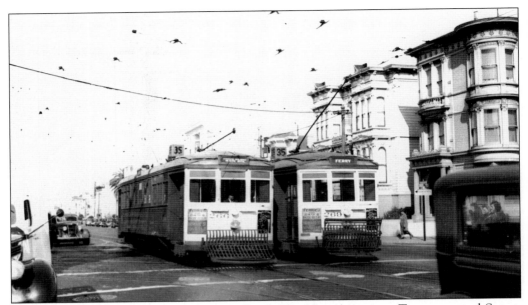

Two cars on the 35-Howard Line pass on South Van Ness Avenue at Twenty-second Street. This was one of the last horsecar lines to be converted to cable car and one of the earliest cable lines to be changed to streetcar in 1897. When the franchise expired in 1939, Muni made it its first trolley coach line.

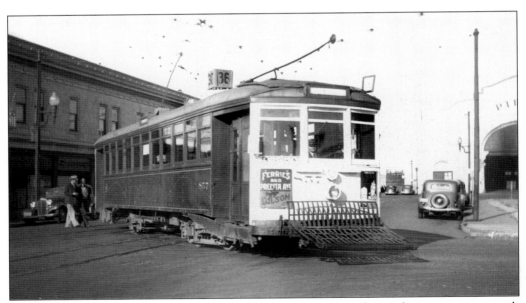

The 36-Folsom Line was one of several of the MSR's money-losing lines operating south of Market Street. The lines were generally retained for franchise related purposes. (Photo by Tom Gray.)

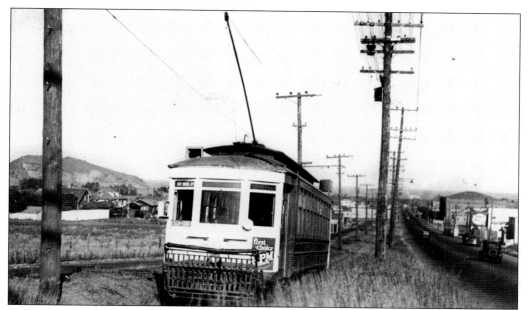

Rolling east on the Visitation Valley Line alongside Geneva Avenue is No. 735 of the Market Street Railway. The scene is relatively pastoral compared to today's development of the area.

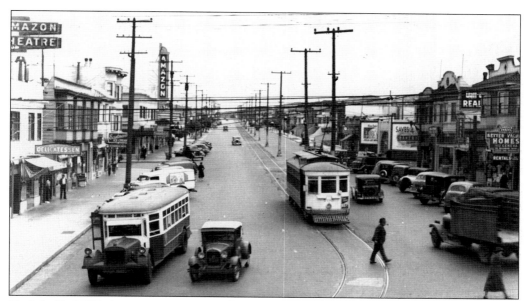

On July 31, 1937, the camera was pointed east on Geneva Avenue from Mission Street, and an early day MSR bus was replacing the Visitation Valley streetcar line. A serious accident on this line led to the city's two-man ordinance. (Photo by Lorin Silleman.)

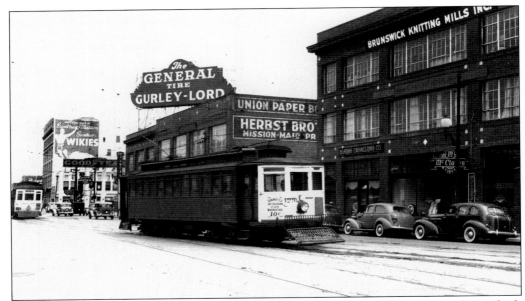

One of MSR's best remembered—and most beloved—lines was the 40 Line interurban, which ran out Mission Street to Daly City and on to San Mateo, 20 miles long. Here No. 1230 turns off Mission on a short cut via Otis Street.

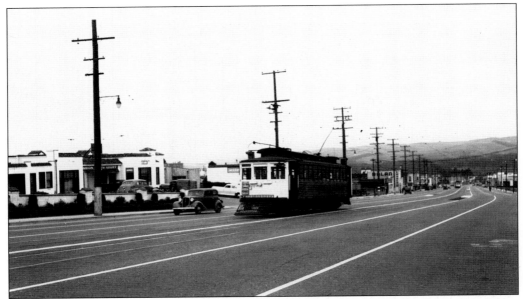

MSR's 1225–1244 series of cars inaugurated service to San Mateo in 1903, but were relegated to city service after the 1906 fire when they were replaced by the Big Subs. In 1923 the 1225s returned for good on the 40 Line. This photo is from 1940. Note the few automobiles and the undeveloped hills.

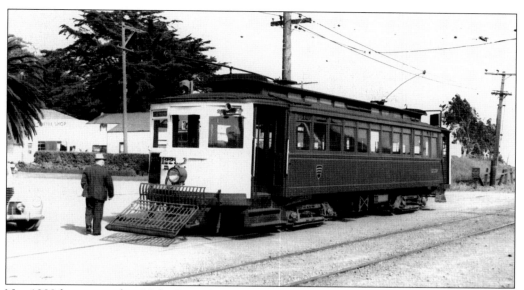

No. 1229 has stopped at Holy Cross Cemetery in 1940. The 40 Line cars did not always wear their headlights. These were arc lamps that were kept at Geneva Carhouse and were placed on the cars only when the runs involved night work before returning to the carhouse.

It took about 79 minutes to cover the 20-mile trip, due mainly to traffic conditions on Mission Street in the city. However, once on the open right-of-way a motorman could "wind 'er up." The Duck Ranch was just south of Holy Cross. (Courtesy of thelate Stephen D. Maguire.)

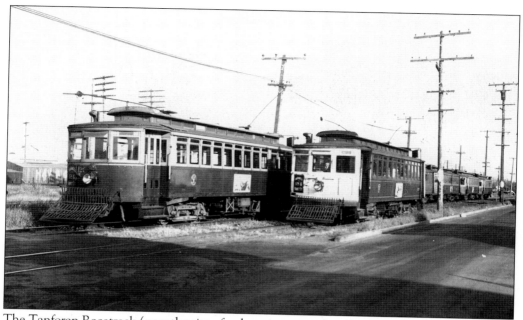

The Tanforan Racetrack (now the site of a shopping center) in San Bruno was a good source of revenue for the 40 Line. Here a lineup of cars awaits the end of the day's horse racing to bring fans back to San Francisco.

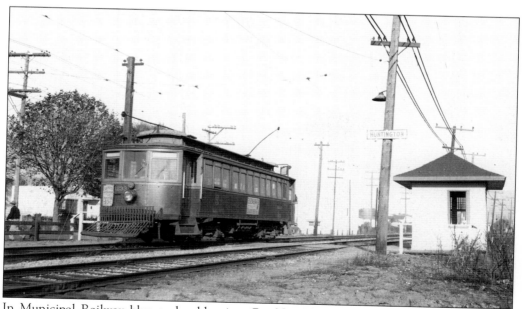

In Municipal Railway blue and gold paint, Car No. 1223 stops at Huntington Avenue in San Bruno.

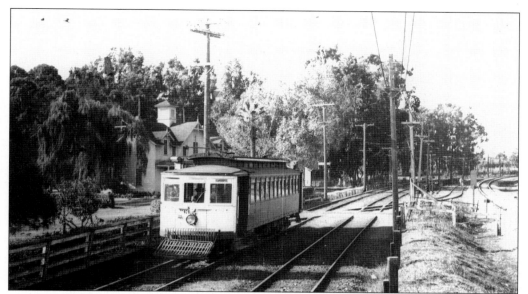

MSR No. 1233 passes the Millbrae Dairy in 1939. Over the years the 40 Line staved off competition from the Southern Pacific (at right) and various bus companies. The 1949 abandonment of streetcar rails on Mission Street in the city left the interurban with nowhere to go. (Courtesy of the late Stephen D. Maguire.)

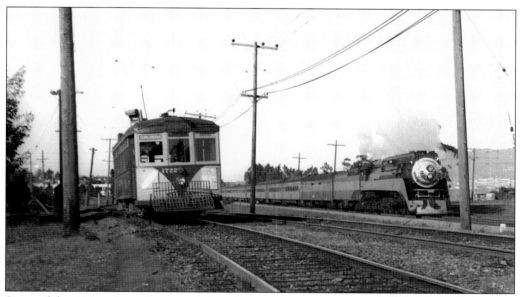

Some of the 40 Line's trackage paralleled that of the Southern Pacific. In this photo we see the SP's crack Los Angeles-San Francisco train, *The Daylight*, with streetcar No. 1722, which was refitted to work the 40 Line's wide open trackage.

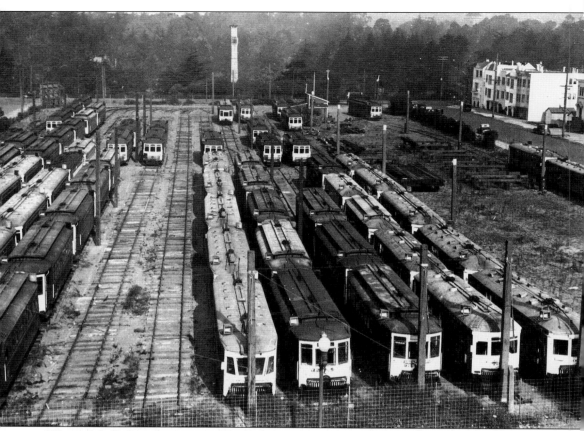

Where did all the streetcars go? To the boneyard! This square-block site was purchased by the United Railroads in 1905 when the Sunset District was sand dunes, but the original intent to build a supersized carhouse was never fulfilled, due to putting resources into rebuilding after the 1906 fire. For years it was a boneyard for old, worn-out, and obsolete equipment until the 1950s when the property, bounded by Lincoln Way, Irving Street, Funston, and Fourteenth Avenues was sold for development.

Five

DOWN MARKET STREET
TO THE FERRIES

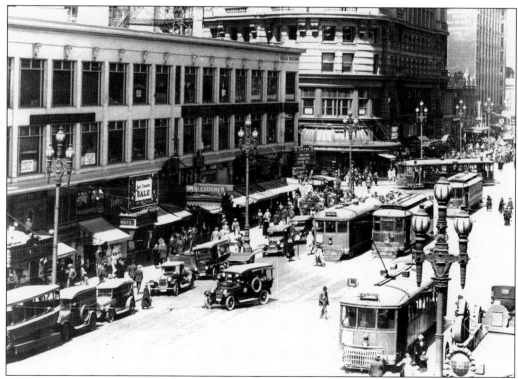

As if increasing streetcar and foot traffic weren't enough, the prosperity of the 1920s brought even more automobiles to compete for space on San Francisco's main thoroughfare.

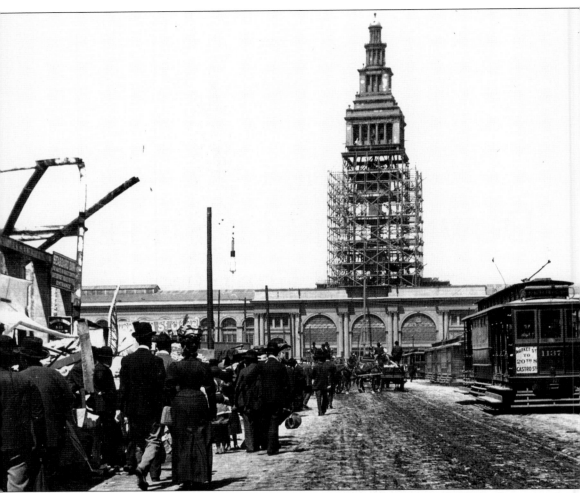

Fortunately, the cable car roadbed for the Market Street lines was built like a fortress and withstood the 1906 earthquake so well that within weeks streetcars were rolling on Market Street—using the cable car tracks. The ferryboat services continued even as the tower on the Ferry Building was being repaired.

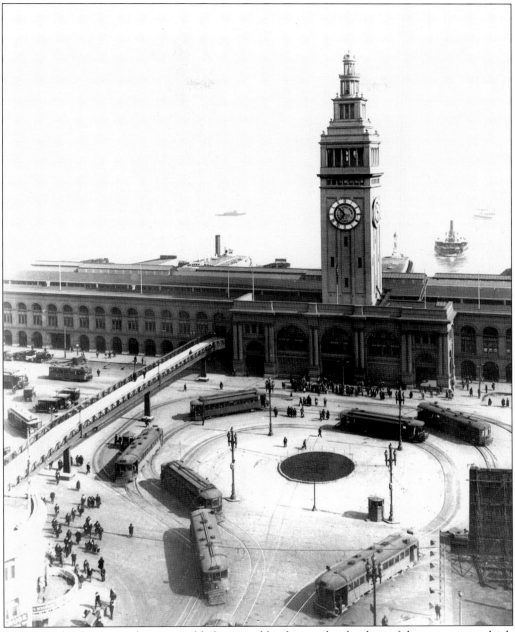

In 1919 a third streetcar loop was added to speed loading and unloading of the streetcars, which were about to serve the second busiest passenger terminal in the world.

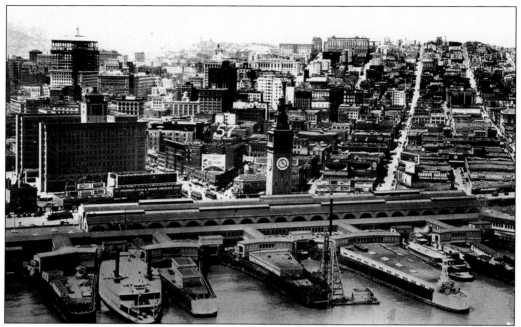

Ferries from around San Francisco Bay converged at the Ferry Building's eight ferry slips to meet the city's streetcars and cable cars. The twin stacker at left is a Southern Pacific vessel and the ferry at right is from the Key System. The large U-shaped building in back of the SP ferry is the headquarters of the Southern Pacific—other landmarks were yet to be built.

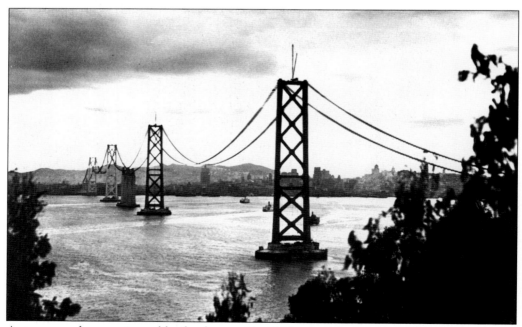

As towers and suspension cables for the new Bay Bridge rise, the ferries are doomed. How many could have foreseen the bridge's impact on public transportation, demographics, and economics over the next half century?

110

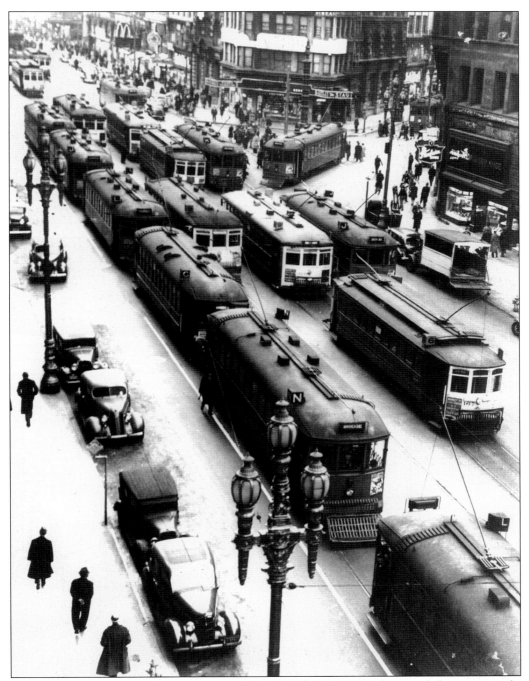

The inside tracks on Market Street were for the Market Street Railway and the outer tracks were for the Muni. In rush hours the prodigious traffic was called the "Roar of the Four," and somehow that streetcar on Geary Street has to cross three tracks to get to the outside track at left for the Ferry Building.

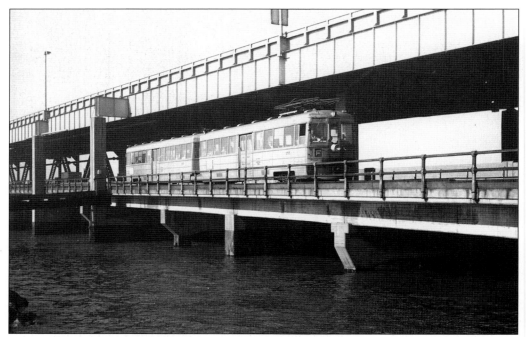

In 1956 the Key System's Bay Bridge trains had less than two years left. Patronage was in decline and the Toll Bridge Authority wanted to convert the railway into traffic lanes. Planners were already thinking of the Bay Area Rapid Transport (BART). Today's traffic sufferers lament, "Why did they ever get rid of the Key System?"

Key System No. 187 heads a train across the lower deck of the Bay Bridge from downtown Oakland to San Francisco. The Bridge Railway was an engineering marvel, designed to handle three railways at two different voltages. (Photo by Randolph Brandt.)

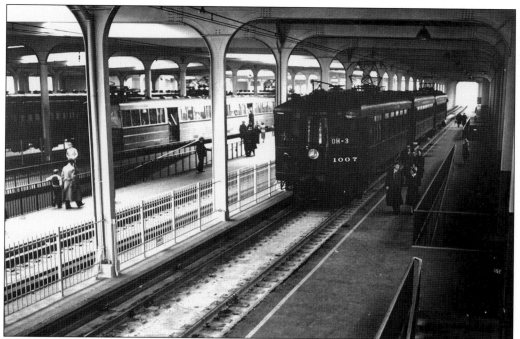

On January 30, 1939, the trains of three interurban railways were inside the East Bay Terminal. At far left is the Interurban Electric Railway, then the Key System, and at right is the Sacramento Northern on Track 6. (Courtesy of Moulin Studios photo for California Toll Bridge Authority.)

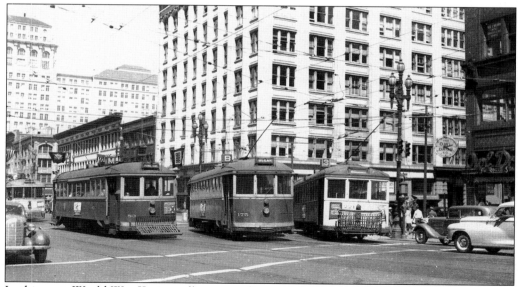

In this post–World War II view, all streetcar lines are part of the Municipal Railway. A former MSR car on the 3 Line is turning into First Street, along with Muni's B-Geary car, for the East Bay Terminal one block away.

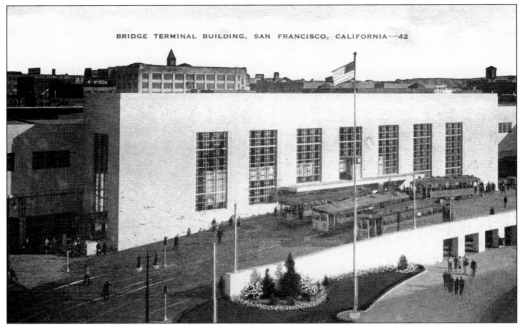

BRIDGE TERMINAL BUILDING, SAN FRANCISCO, CALIFORNIA—42

The streetcars of the MSR and the Muni loop to pick up and let off passengers of the Key System, Sacramento Northern, and Interurban Electric Railway with the same efficiency once reserved for the Ferry Building's loops.

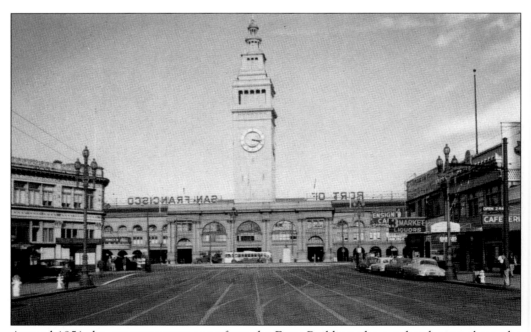

Around 1951 the streetcars were gone from the Ferry Building, the overhead wires above the tracks were gone, and the Ferry Building was deserted, save for a lonely trolley bus. Trolley coaches replaced many of the city's streetcar lines during this time.

Six

SPECIAL CARS
AND SPECIAL RIDES

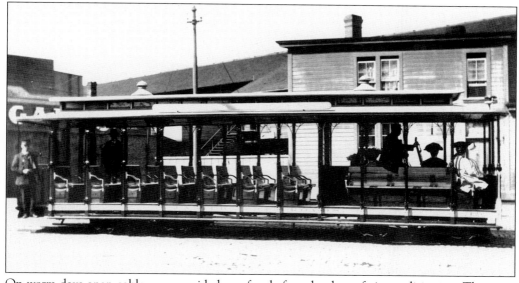

On warm days open cable cars provided comfort before the days of air conditioning. The open cars' major drawback was their uselessness in inclement weather, leaving an investment idle in the carhouses. (Courtesy of the late Charles A. Smallwood.)

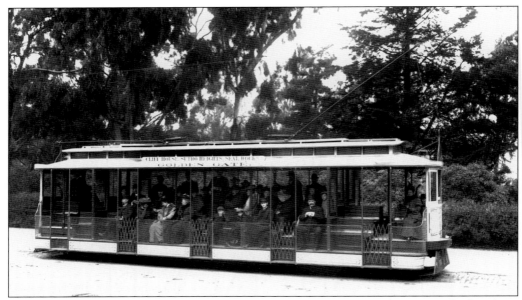

The Market Street Railway introduced sightseeing car service on March 31, 1901 for four-hour tours of the city, two trips per day, fare at 25¢ and no transfers. This car was named *Golden Gate*. (Courtesy of San Francisco Public Utilities Commission.)

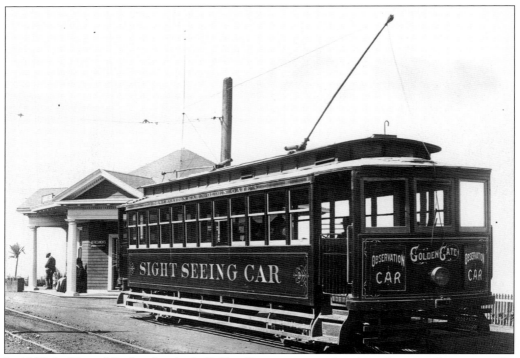

In 1905 the United Railroads rebuilt *Golden Gate* into an enclosed car that seated more people. Here the *Golden Gate* is at Land's End Station before the services ended in 1917. (Courtesy of the late Charles A. Smallwood.)

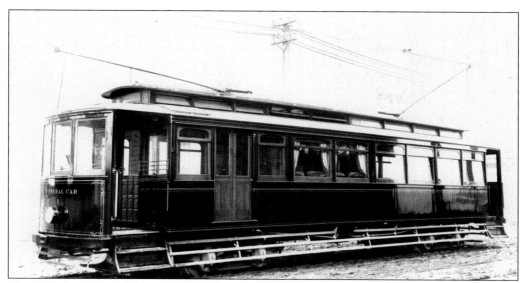

The URR built several funeral cars in their shops, such as No. 1 shown here. There was a special compartment for the dearly departed, and mourners rode in style as in the party cars. They were ended in 1921 due to increased use of automobile hearses. (Courtesy of the late Charles A. Smallwood.)

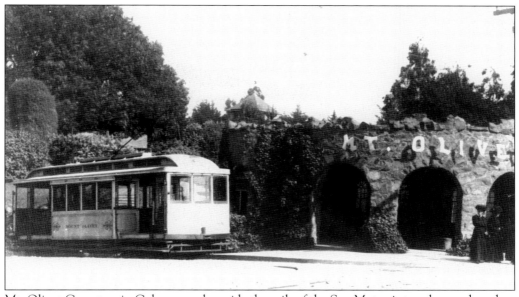

Mt. Olivet Cemetery in Colma was alongside the rails of the San Mateo interurban and used an old United Railroads streetcar on its private railway around the grounds.

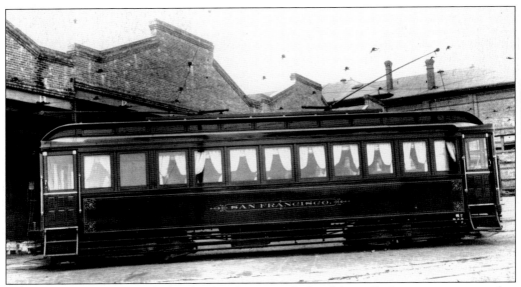

The *San Francisco* was made for the San Francisco & San Mateo Railway as a streetcar, but was rebuilt in 1902 into a party car. It was chartered by people of means for such duties as parties, attending the opera, or going to championship prize fights. (Courtesy of Charles A. Smallwood.)

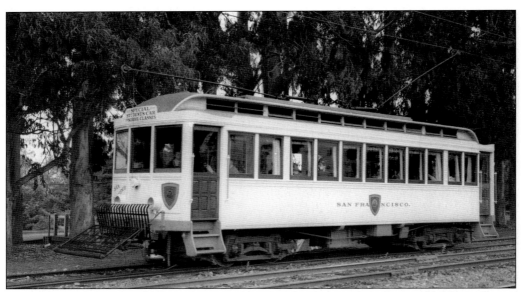

In the 1920s the MSR rebuilt *San Francisco* into a school car and made it available for free to the city schools for field trips and for care facility patients' outings. In this 1948 view, *San Francisco* is on a charter on the 40 Line in Burlingame. (Photo by Tom Gray.)

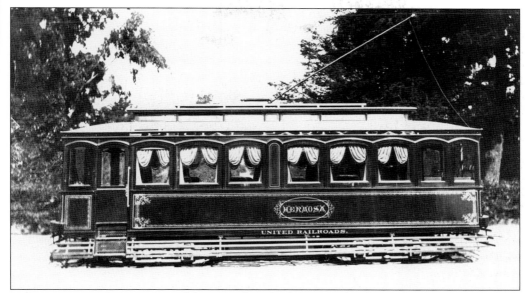

Hermosa was another party car of the URR fleet, built in 1898 for the Market Street Railway. In 1919 *Hermosa* was rebuilt into a city streetcar. *Hermosa* was shorter than the *San Francisco*. (Courtesy of the late Charles A. Smallwood.)

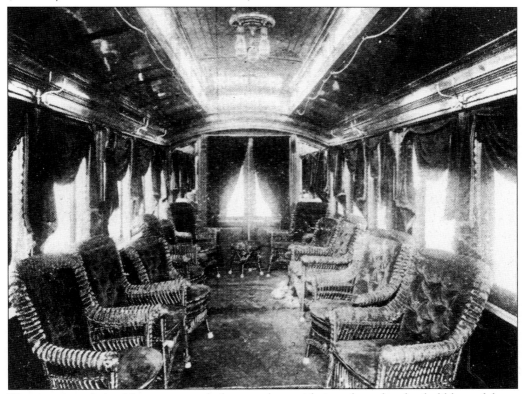

The interior of the *Hermosa* was plush, complete with ice chest for the bubbly and brass cuspidor on the carpeted floor. (Courtesy of the late Charles A. Smallwood.)

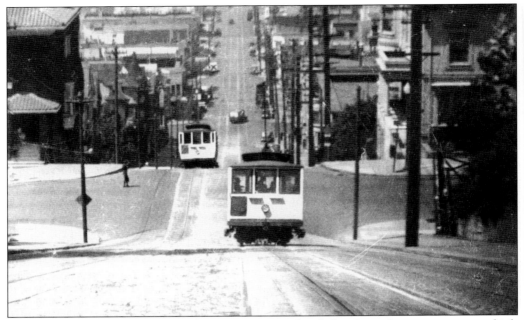

The extremely steep grade on Fillmore Street mandated this funicular arrangement, which lasted from 1895 until 1941. Two cars hooked on to an underground cable and operated as a combination of electric streetcar and cable car, counterbalancing each other.

To start the day, two cars went down in tandem, counterbalanced by a weighted dummy car going up. The counterbalance line was for only the two blocks between Broadway and Green Street while the rest of the one-mile trip was made by the cars acting as conventional trolleys.

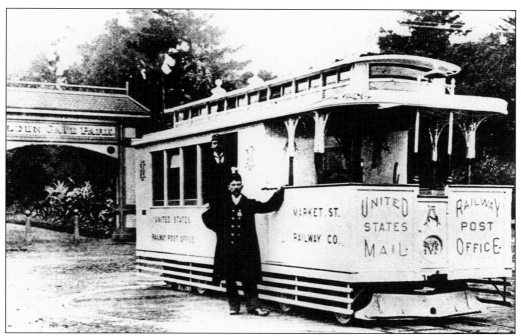

Cable cars also carried U.S. mail.s With a surplus of rolling stock that could be rebuilt in the company's shops and a need to deliver mail to district post offices faster than a team of horses could do the job, why not? This practice ended in 1906.

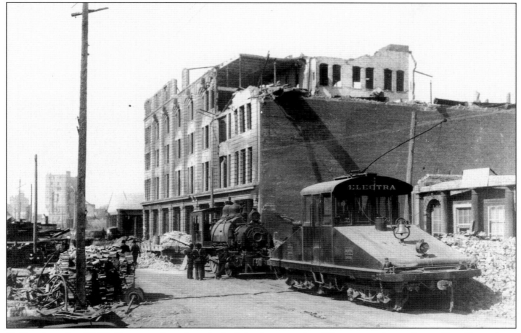

Following the 1906 disaster, the electric freight locomotive *Electra* was brought to San Francisco from the North Shore Railroad in Marin County, teaming with Western Meat Packing locomotive No. 1 for debris clearance work, making it one of the oddest trains in the city.

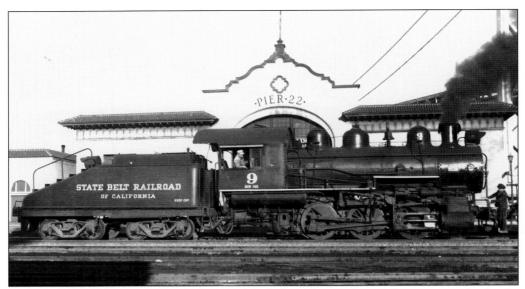

The State of California ran a switching railroad along the city's waterfront to transfer freight cars loaded with cargo to and from ships to the various main line railroads. Here State Belt Railroad 9 Spot is in front of Pier 22, south of the Ferry Building, in 1938.

In 1962 the Municipal Railway celebrated its 50th anniversary by restoring Car No. 1, the first publicly owned and operated streetcar in America, and running the car on Market Street. No. 1 today is an active part of the Muni's historic fleet. (Photo by Paul C. Trimble.)

Seven
INTO MODERNITY

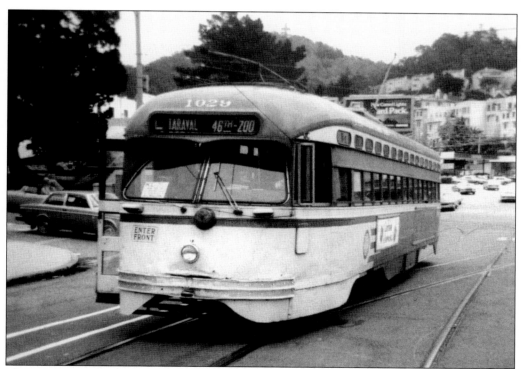

The PCC model streetcars, while slow to arrive in San Francisco, quickly became the Municipal Railway's mainstays, such as No. 1129 on the L-Taraval Line on Ulloa Street, pictured here February 18, 1980. (Photo by Paul C. Trimble.)

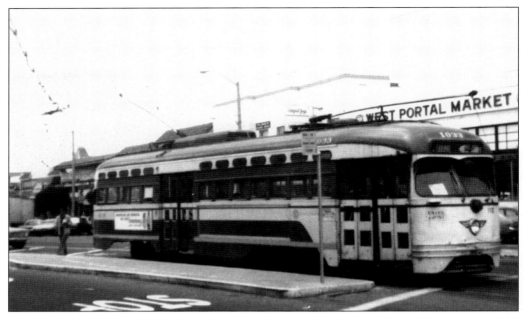

PCC streetcar No. 1033 was part of a job order for 25 cars from St. Louis Car Company in 1952, which turned out to be the last conventional streetcars built in the United States. The car is on West Portal Avenue on February 18, 1980. (Photo by Paul C. Trimble.)

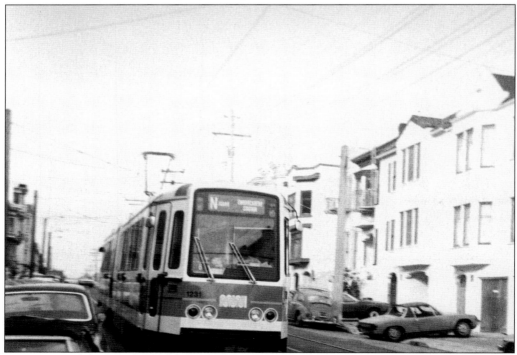

Boeing-Vertol–built Light Rail Vehicle (LRV) No. 1231 was one of the cars assigned to the N-Judah on the line's first full day of LRV service on a foggy February 18, 1980. The car is inbound on Carl at Stanyan Streets. (Photo by Paul C. Trimble.)

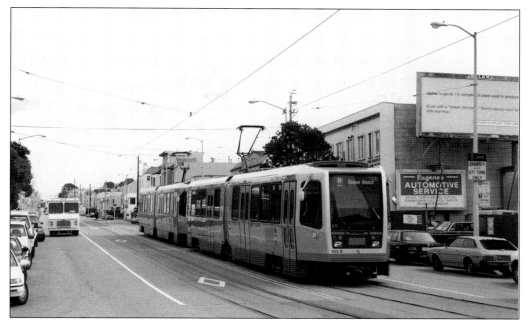

San Francisco's latest version of street rail transit is represented by this train of LRV's No. 1432 and No. 1433, going inbound to downtown on the N-Judah Line on Judah Street at Forty-fifth Avenue, shortly before noon on February 20, 1998. (Photo by Paul C. Trimble.)

As the MSR's 22-Fillmore Line once served Seals Stadium and the 20-Ellis Line served the Southern Pacific Depot, LRV's on the Muni now serve the Giants' new baseball stadium on the site of the SP's old roundhouse and the CalTrain Depot. (Photo by Paul C. Trimble.)

Municipal Railway streetcar No. 130, built in 1914, was restored from wrecker car status in time for the first Trolley Festival in 1982 and continues in active service on the F Line, shown here on Jefferson at Taylor Streets at historic Fisherman's Wharf in 2000. (Photo by Paul C. Trimble.)

Muni's historic fleet includes reconditioned PCC streetcars from Philadelphia, painted as replications of streetcar operators from across the United States. Photographed on Seventeenth Street in 1995 is No. 1053, representing Brooklyn, New York, where PCC streetcars first ran in revenue service. (Photo by Wilbur C. Whittaker.)

Are these cable cars old or new? The double-end cable car on California Street (right) was built in 1906 for the California Street Cable Railroad following the loss of rolling stock during the fire. The single-end cable car on Powell Street (left) was built in the Muni's shops in 1990, following the original patterns and using salvaged hardware from the past. (Photo by Paul C. Trimble.)

Let us not forget there once was a time when cable cars in San Francisco were primarily for public transportation and not for tourism…

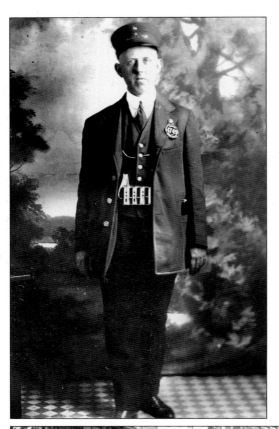

When streetcar conductors and motormen posed for formal portraits in their uniforms, complete with pillbox caps, gold watch chains, coin changers, ticket punches, and company badges…

And when streetcars took people everywhere they needed or wanted to go in the city by the Golden Gate.